MW00786078

acrylic
color
explorations

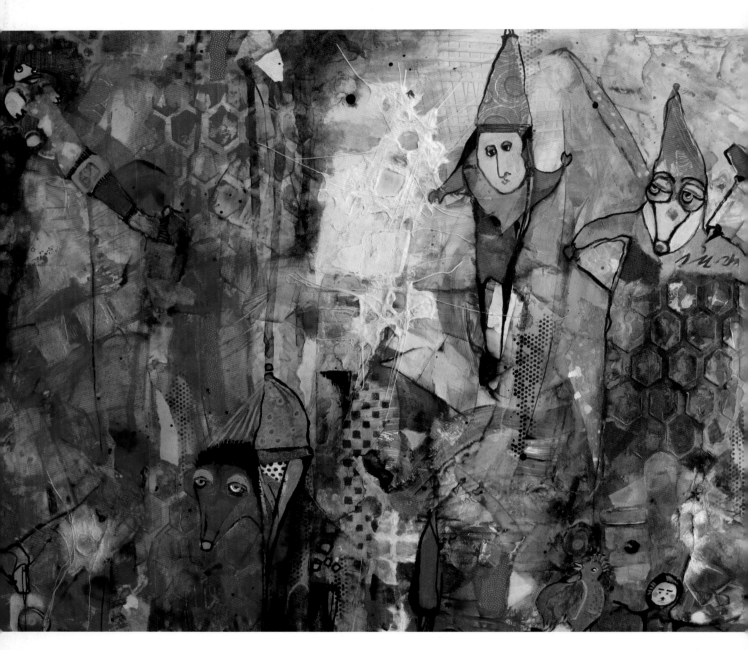

SEND IN THE CLOWNS
Chris Cozen
Acrylic and mixed media on Yupo
30" × 22" (76cm × 56cm)
Both warm and cool high-intensity colors were used to create
an energetic environment for the clowns. Pattern and line add to
the lively composition and provide visual direction.

acrylic color exploration[s]

acrylic color

explorations

CHRIS COZEN

NORTH LIGHT BOOKS
CINCINNATI, OHIO
www.artistsnetwork.com

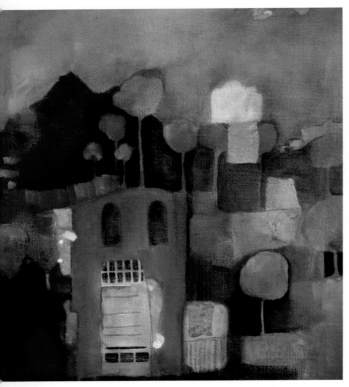

BLUE VILLA
Chris Cozen
Acrylic on unstretched canvas
14" × 14" (36cm × 36cm)
Sheer color glazes in varying tones of blue and purple
were used to pull shapes out of the background and define
spaces within the shapes. The touches of bright yellow-gold
provide a sharp contrast to the overall cool composition.

CONTENTS

WHAT YOU NEED

Surfaces

black gesso panel
canvas (optional)
Gelli plate print
painted surface
panels or boards
paper
Yupo surface

Pigments

Anthraquinone Blue
Aureolin Hue
Bone Black
Burnt Sienna
Burnt Umber
Burnt Umber Light
Carbon Black
Cerulean Blue
Cerulean Blue Deep
Cobalt Turquoise
Dioxazine Purple
Fluorescent Pink High Flow
Graphite Gray
Hansa Yellow
Hansa Yellow Light
Hansa Yellow Medium

Hansa Yellow Opaque
Indian Yellow Hue
Interference Blue
Iridescent Gold
Iridescent Gold Deep
Iridescent Pearl
Iridescent Stainless Steel
Magenta
Mars Yellow
Micaceous Iron Oxide
Naphthol Red Light
Naphthol Red Light High Flow
Naphthol Red Medium
Naples Yellow Hue
Neutral Gray N5
Payne's Gray
Permanent Violet Dark
Phthalo Blue
Phthalo Blue (Green Shade)
Phthalo Green
Phthalo Green (Blue Shade)
Phthalo Green (Yellow Shade)
Pyrrole Red

Prussian Blue Hue
Quinacridone Nickel Azo
Quinacridone Nickel Azo Gold
Quinacridone Magenta
Raw Umber
Red Oxide
Sap Green Hue
Teal
Titan Buff
Titanium White
Transparent Pyrrole Orange
Transparent Red Iron Oxide
Turquoise
Turquoise Phthalo
Ultramarine Blue
Yellow Ochre

Brushes

brushes, assorted
fine-tipped brush
pointed, short bristle brush
small flat brush

Other Supplies

Acrylic Glazing Liquid
Acrylic Ground for Pastels
acrylic skins (optional)
alcohol
assorted papers
brayer
bubble wrap
Catalyst tool
Coarse Molding Paste
color wheel
comb or carving tool with teeth
deli sheets
dropper or cotton swab
ephemera: maps, pages, vintage stamps
Fluid Matte Medium
gel medium
Gelli plate
Glass Bead Gel
glazing liquid
knitting needle, chopstick or pointed tool

Light Molding Paste
makeup sponge
mark-making tool
Origami Mesh paper
painted panel
palette knife
palette paper or mixing surface
papers, assorted
pencil
piece of art
rigid surface covered in plastic
rubber tool or comb
scissors
scraper, rubber
scratching tool
Soft Gel (Matte)
sponge
spray bottle of water
stamp, rubber
stencils
straw
white pen or chalk

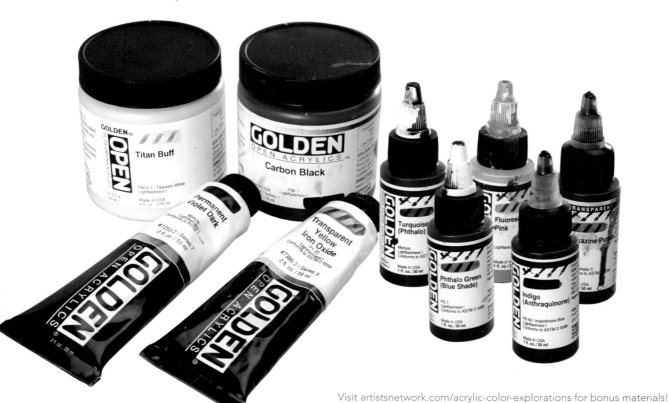

INTRODUCTION

I love color and I want you to love it too. There is no need to spend your life in the limited company of a few colors or to fear making sound color choices. There is a world of color information waiting for you to explore that will expand your knowledge, give you color confidence and bring new dimensions to your own artful practices.

In his book *On the Road*, Jack Kerouac wrote, "Soon it got dusk, a grapy dusk, a purple dusk over tangerine groves and long melon fields; the sun the color of pressed grapes, slashed with burgundy red, the fields the color of love and Spanish mysteries." When I read that line I wanted to jump up and paint it. It spoke to me in color. Reading the words allowed my mind to see what he was writing. Color vibrates, it resonates, clashes and converses. Color conveys emotion from happiness and joy all the way through sadness and remorse.

> "color! what a deep and mysterious language, the language of dreams."
> —Paul Gauguin

As a painter and a teacher, I want to know as much as I possibly can about color. I want to understand how to make the most of paints and pigments and the relationships between colors. The best and most direct way to learn what you need to about color is to get out your paints and begin to experience the voices of the pigments. The more you experiment, test, push, mix and adjust, the more you will learn.

When I gave myself permission to make color mistakes, I learned to be fearless about color. Becoming fearless about color gave me a certain freedom in my work as well as the confidence to explore color without reservation. As a result, when I do make mistakes, I now understand how to make adjustments before I veer too far off course. There is so much to understand about how to utilize the many voices of color, how to manage and adjust it, how to fully utilize all the nuances. In this book I have collected color-mixing recipes and exercises, lessons and experiences to share with you. I hope they will help you to become fearless about color as well.

This book is also a guide to understanding how color "speaks." Together we will look at the calm and collected groups of colors, explore the polar opposites and learn how to create nuance and subtlety. We will push past the color wheel and open up color conversations that range from whispers to shouts. There will be opportunities for you to try new ways of working with colors through color-mixing and color-modifying exercises, and pattern development in both paint and mixed-media applications.

I will introduce you to various artists, both established and emerging, whose work will emphasize a color lesson or a particular application of color. I hope their work will inspire and enthuse you to try different techniques, color combinations or styles of painting.

Along the way you will encounter quotations about color by some well-known artists who have inspired me and explore how their own work reflected the voices of the colors they used. Whether you choose colors that whisper or shout, sing or chant, I am confident that these pages will serve to expand your understanding and use of color.

Chris Cozen

INDIAN SUMMER
Chris Cozen
Acrylic and mixed media on board
20" × 16" (51cm × 41cm)
Tones of yellow mingle delightfully with a high-impact magenta to create an ambience of a late fall garden, resplendent with leaves and pods. A cool aqua green adds a bit of contrast to the overall warmth of the composition.

1 color ESSENTIALS

There is a language associated with understanding color, and it is important that we learn to speak it. Knowing your way around the color wheel is a great place to start. Becoming familiar with the terms used to describe the various aspects and dimensions of color will give you the confidence to make the colors you love do what you want them to do.

Check out artistsnetwork.com for free demonstrations and extra content.

REMEMBERING TUSCANY

Chris Cozen
Acrylic and mixed media on canvas
18" × 18" (46cm × 46cm)
Strong, straight brushstrokes were used to build this view of a hillside village in
Italy. The turquoise, yellow and green accents play well off the intense red back-
ground evoking the late afternoon sun. Areas of darker color, collage elements
and line work assist the eye in visually understanding the abstract spaces.

PRACTICAL INFORMATION ON COLOR

When we talk about color a lot of words get tossed around and a lot of questions need answers, such as: What about pigments? Where do they come from? What are their properties? What does lightfast mean? Are these paints archival? What is pigment strength? Many terms are used to describe color: hue, chroma, saturation, shade, tint, tone, value and temperature.

Let's try to get some answers.

Color Pigments Through Time

When we look at the first use of color in art, we must travel back in time to cave paintings. A charred bone taken from the fire led to making marks. Substances gathered from the earth were combined with water or animal fats to create "paint" that was used to apply color to the marks made on walls telling the stories of life. The discovery that colors could be created from natural substances led to a search for more variations in color beyond the initial clay and charcoal used, which continues to today.

Among the oldest pigments still in use today are Red Ochre, Yellow Ochre, Umber, Carbon Black, Bone Black and Lime White.

As time went on, more pigments were pulled from the earth. Clay, soil, mineral deposits, iron ores, oxides, heavy metals, lead and even semiprecious stones were all put into use as pigments. Some of these pigments were stable and over time retained their true colors. Others came to be known as *fugitive pigments* having the characteristic of poor lightfastness, leaving only ghosts of their true color behind or, worse yet, disappearing altogether over the years.

The ancient Egyptians developed many bright colors, some of which are still in use. Although prone to fading, Indigo, the dye traditionally used for coloring blue jeans, is still in production today. They also created cochineal dyes derived from insects to create memorable red colors, a brilliant yellow that was derived from arsenic, and even a synthetic dye called Egyptian Blue.

There were many other cultures that gifted the world with pigments and dyes. The Greeks provided the first colorants derived from lead: a brilliant white and a scarlet red. Numerous other colors based on lead formulations were developed and used for centuries until the poisonous qualities of lead paint were discovered and its use was thankfully discontinued.

Prussian Blue was accidently discovered when experimenting with the oxidation of iron in the early 1700s. This modern synthetic pigment would mark the beginning of a time of experimentation and lead to the discovery of many colors still in wide use today.

The Industrial Revolution led to a period of excitement about color as discoveries of how to coax color from chemicals seemed to explode. In fact, many of the modern pigments that make up our paint box selections today have origins from a chemistry lab.

Today artists still use many of the original pigments discovered when man was painting on cave walls, and new pigment variations have been added to the list. But many of the old pigments utilized by generations of artists are no longer in production due to issues of toxicity, which made them dangerous and sometimes even fatal to those who used them.

Fortunately, today there is a grand variety of safe synthetic pigments from which to choose. We have the best of both worlds with safety standards in place to protect us from potential harm and pigments that are consistent, readily available and manufactured responsibly. Buying your paint from responsible manufacturers with a reputation for quality production of materials is always recommended. This will guarantee that your work will stand the test of time and your health will be protected.

From left to right: Nickel Azo Yellow (transparent), Hybrid mix, Yellow Ochre (opaque).

Pigment Qualities

Knowing where your pigment originates can give you a heads up about its color properties.

Earth Pigments

As mentioned earlier, many pigments have their beginnings in natural formation here on earth as rock, earth, mineral, ore, etc. These chunky, earth-based pigments have a set of unique color behaviors that influence their appearance. In general, when applied to a surface, they produce a solid film of opaque color with low chroma. Chroma refers to the brightness or dullness of a color. Earth pigments mix well with other colors in this range with the resulting secondary and tertiary colors demonstrating their signature low chroma, lending them to softer, more subtle color blends and applications.

When using an earth-based pigment, you can expect to see color that is less bright, has a dull or flat surface sheen and opaque qualities of coverage. I frequently refer to this group of pigments as being able to "color and cover." They are ideal for blocking out large areas of color, covering up areas where you have made mistakes and building a strong foundation for future layers of color as they work well to ground a painting. These pigments can be made less opaque by thinning them with a clear glazing medium.

Modern Pigments

Chemically formulated pigments with their vivid high chroma color and transparent qualities are well known for their clear, vibrant mixability. The range of pigments in this category is expansive and very tempting to anyone as color hungry as I am. Because the pigment particles are sheer, light easily passes through them creating clear and bright mixtures.

Since these colors have such high chroma they tend to speak very loudly when used. Some of the modern pigments are so deeply pigmented that their sheer qualities are masked by the strength of the pigment when they are viewed in mass tone. (Mass tone refers to the color of a paint when it is applied thickly and not spread out.) You can check the transparency of any pigment by introducing a glazing medium to the color, and the sheerness of modern pigments makes them perfect for glazing.

In Tandem

A color mixed from an earth pigment and a modern pigment will result in a hybrid color. This hybrid will demonstrate an adjusted chroma that is greater than the single earth pigment but less than the single modern pigment. The transparent qualities of the chemical pigment will be modified by the light-absorbing nature of the opaque earth pigments. This hybrid color is a good way to bring down the volume of the modern pigments while increasing the chroma of the earth pigments.

BASIC COLOR TERMS

A number of terms come up in the vocabulary of most artists time and again. This basic list gives you working definitions of these key terms and will prove valuable as you move through these pages.

Color What we see when we look at objects, people and landscapes. It includes the full spectrum of the rainbow.	**Archival** The quality or permanence of art materials in general. Archival paper has a neutral or slightly alkaline pH, good aging qualities and is usually made of 100 percent pure natural materials like cotton or linen.	**Pigment** The raw material, either natural or synthetic, containing color that is added to a binder to create paint. Pigments also have names such as Cadmium Yellow, Nickel Azo Yellow, Yellow Ochre and Hansa Yellow Medium.
Value The lightness or darkness of a color, tint or shade.	**Hue** Another word for color. By adding a descriptor word to a color, we can describe the color more specifically: Yellow is a color; Lemon Yellow is a more specific color of yellow.	**Shade** The color that results when black is added to a hue.
Tone The color that results when a neutral gray is added to a hue.	**Tint** The color that results from the addition of white to a hue.	**Tint Strength** The ability of a color to maintain its strength when another color, such as white, is added to it.
Color Temperature The warmness or coolness of a color. We think of red, yellow, orange and some browns as warm. They evoke sunshine, fire and heat. Blue, green and violet are cool colors. Individual pigments within a single hue can have different temperatures. Quinacridone Red is a cool red. Cadmium Red is a warm red. Warm colors advance; cool colors recede.	**Chroma/Saturation** Refers to color in its natural form, the brightness, strength or intensity of a color. A fully saturated color has no white, black or gray. **Grayscale** The range of tones from dark to light that is created when black is mixed with white. The tones are referred to as neutral grays.	**Lightfastness** The permanence of a pigment. If a pigment retains its color after many years of being exposed to light, then it is lightfast. There are technical standards for measuring the lightfastness of artist pigments. Look for a rating of 1 or 2 when choosing paint. Pigments that fade when exposed to light are known as *fugitive pigments* and are not stable.

THE COLOR WHEEL

The placement of the colors around the color wheel along with their proximity or distance from one another helps us understand contrast. When you focus on one color then look directly across or opposite from it, you will find its complement, a color with high contrast to the first color. Colors far away from each other on the color wheel have the greatest contrast. Colors adjacent to each other on the color wheel have the lowest contrast. They are analogous colors and have a likeness for and to each other. There will be more on these relationships as we progress.

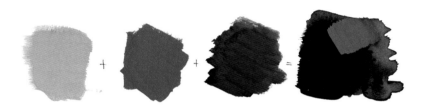

The Primary Colors
Red, blue and yellow are the single voices in the color wheel. They cannot be mixed using any other colors. They are continuously involved in multiple color conversations as they interact with each other and with the colors that are created between and amongst them. Mix them all together and you can create a chromatic black.

The Secondary Colors
These colors are created when the primaries mix with each other. Therefore, red and yellow create orange; blue and yellow create green; red and blue create violet. These colors are also strong voices within the color wheel with the added advantage of having additional nuance as a result of their combined voices. Mixing a primary and a secondary color together will lead you to a brown.

Tertiary or Intermediate Colors
These colors are created when the secondary colors are mixed, giving us red-orange, yellow-orange, yellow-green, blue-green, blue-violet and red-violet. Each of these colors contain varying portions of two of the primaries, creating a range of colors between each of the primaries around the wheel and making up the last of the six slots in the wheel.

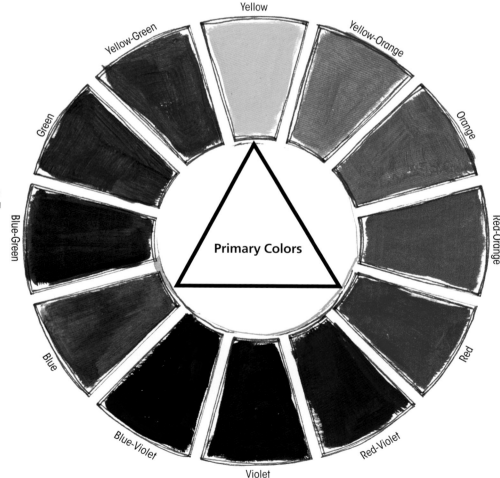

THE VERSATILITY OF CHROMATIC BLACKS

There is a world of blacks that can be mixed from various colors. These chromatic blacks are made by combining more than one pigment in varying ratios. They provide unique alternatives for single pigment blacks, which are quite exciting especially when used in wet or glaze applications. When you add a chromatic black to another pigment to darken it, the original pigment is not as overwhelmed as it would be when a single pigment black is used.

Bring interest to your surfaces with these formulas for mixing blacks. Be sure to create a storyboard to record your mixtures. Remember that you can add white to any of these mixtures to create gray.

MATERIALS LIST

assorted paints (see Chromatic Black Formulas)

brush

palette paper or mixing surface

paper

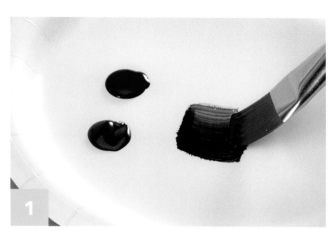

1 Squeeze out an equal amount of paint from each color onto your mixing surface. Mix the colors together, adjusting until the desired chromatic black is achieved. I am using Burnt Umber Light and Ultramarine Fluid Acrylics for this version.

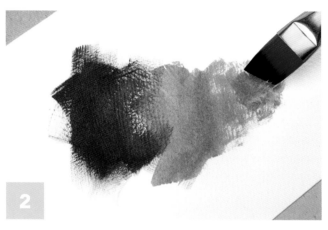

2 Apply the paint to the surface. Introduce some white into your chromatic black mixture to create a chromatic gray.

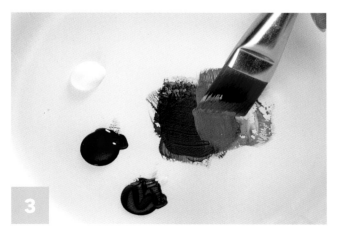

3 Increasing the amount of blue in the mixture will create a cooler chromatic color.

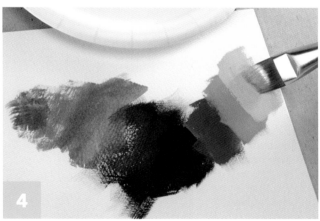

4 Continue adding white to create a range of gray values. Since these grays are generated from your original chromatic black formula, they are all compatible both in tone and temperature.

CREATING NUANCE WITH COMPLEMENTARY GRAY

If ever there were a versatile color, it would be gray. Gray is all about nuance. It reminds me of a room filled with conversation on all levels: Whispered endearments, lively interactions, hushed secrets, jovial laughter. These are the myriad sounds of life.

Gray is comforting, it is quiet, yet it can also be strong. Gray is soft and gentle. It can complement any color because it is drawn from all of them. Gray punctuates and supports the colors of life. You can build from it or you can create life's shadows with it.

If we could see the world in black and white, we would be able to perceive all the values of color in the grayscale. The range of darkest to lightest colors in any composition can be quickly translated into grayscale by taking a digital photo of the painting in process and converting it to a black-and-white image.

Some programs will give you the option to convert to actual gray scale, but I find that simply converting the color image to a black-and-white image is enough for me to see if I am including a full range of values in my composition.

CHROMATIC BLACK FORMULAS

Prussian Blue + Alizarin Crimson +	touch of Hansa Yellow Medium	
Cobalt Blue + Carbon Black		
Burnt Umber Light + Ultramarine Blue		
Prussian Blue + Burnt Sienna		
Burnt Sienna + black		
Naphthol Red Medium + Ultramarine Blue +	Hansa Yellow Medium	
Quinacridone Red + Phthalo Green (Yellow Shade) + black		
Cerulean Blue Deep + Pyrrole Orange		
Hansa Yellow Opaque + Vitramarine Violet		

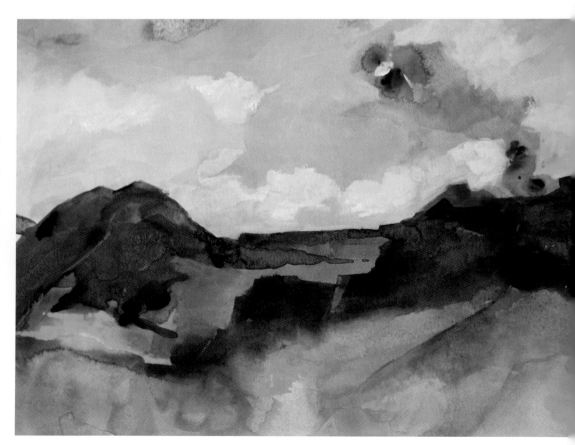

UP
Chris Cozen
Acrylic watermedia on paper
8" × 10" (20cm × 25cm)
This piece was created using the chromatic mixture of Carbon Black and Cobalt Blue plus Titanium White. It shows the versatility of the chromatic mixtures and the range of grays that can be developed with the introduction of white.

demonstration
MIXING COMPLEMENTARY GRAYS

Learning to mix a complementary gray is an artistic gift. This is a gray that can stand alone, be used to tone down colors that are too bright and is also the perfect neutral. It differs from a neutral gray in that you are creating the gray from a color and its complement: red + green, yellow + purple, blue + orange, etc. When you vary the amount of the complements, you can alter the outcome of the gray.

MATERIALS LIST
assorted paints
brush
palette paper or mixing surface
paper

Dab a small amount of Cerulean Blue Deep and Pyrrole Orange onto your mixing surface. (Hansa Yellow Opaque and Ultramarine Violet is another option.)

Introduce the orange in small amounts into your blue pigment until the color begins to shift to gray. Apply the new color to the paper.

Add white to each new mixture and blend the colors to create gradations of gray.

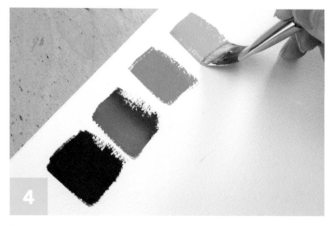

Continue creating values of gray by adding more white.

COLOR CHALLENGE

It is easy to mix a range of primary grays. Start with black, your darkest color, on one end and place white, your lightest color, on the other end. There will be seven steps in between these two. Your middle slot is a one-to-one mix of black and white. Can you figure out how to fill in the remaining four spaces?

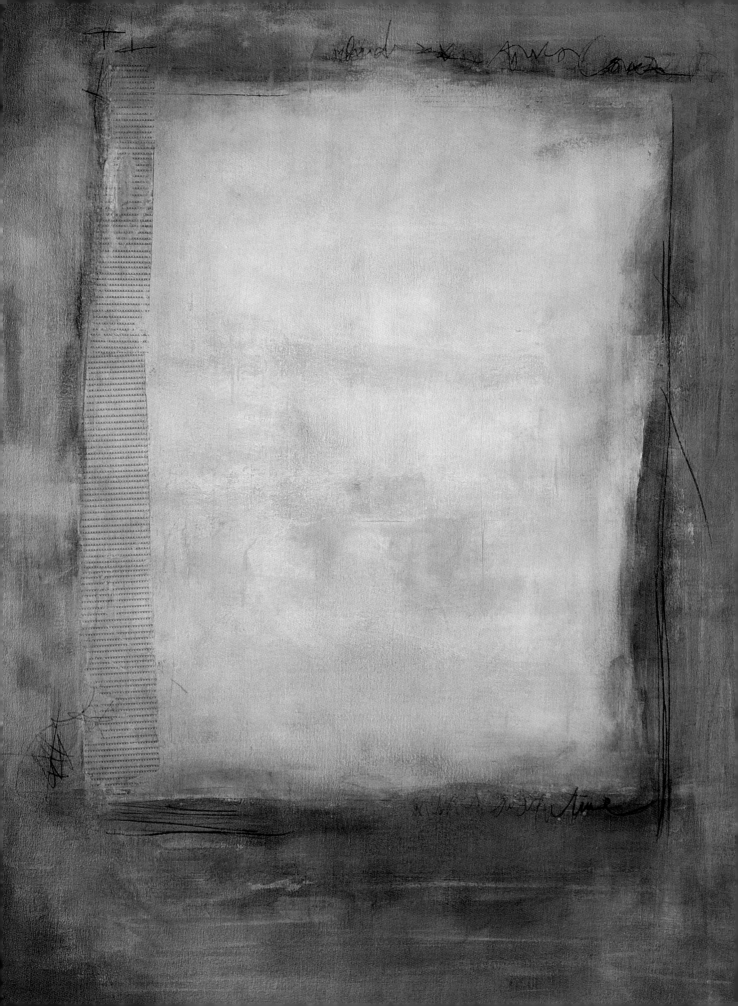

Julie PRICHARD

"There is an ongoing dialogue between the painting and the people who experience... art." –Julie Prichard

Julie Prichard is a force to be reckoned with. She's an artist, photographer and gemologist who resides in San Diego and creates amazing paintings using muted palettes with diffused edges, buried collage layers, scratched-in details and hints of color. Her large-scale pieces command the eye and draw you in to study the details and examine the surfaces.

Julie was once my student and is now a treasured colleague. Together we wrote *Acrylic Solutions: Exploring Mixed Media Layer by Layer* and co-teach a number of online art classes.

Julie's work makes me proud to have been her mentor as she has more than mastered the art of color nuance.

She uses tonal variations and chromatic mixes of black and white to perfection, giving them the respect and importance they deserve. Her keen eye as a photographer allows her to find the nuance, as she says, in "rock formations and weathered piles of wood," which she uses as both inspiration and color reference.

Her work feels beaten and worn. It never screams color, but as Julie tells me, it "might whisper a little something. It is secure in its maturity." As you look closely at her work, you will see the hints of color that lie just beneath the surface. Her technique of layering color is masterful and offers an alternative to constantly working with a

brush. She utilizes a brayer extensively in her pieces with great effect in order to build up the history of her surfaces.

"Whispered color." What a wonderful phrase! Now is the perfect time to do some whispering of our own and try our hand with Julie's color language and techniques.

AFTER HOURS
Julie Prichard
Acrylic and collage on canvas
48" × 36" (122cm × 91cm)

ABOUT
JULIE PRICHARD

Julie Prichard is a self-trained mixed-media artist with a unique background. Trained both in photography and gemology, she has an eye for detail and color which she aptly brings to her own work. She is an active blogger, entrepreneur and business woman who paints when she's not being a mom, playing tennis or managing the many students in the classes she teaches online through her network. She is co-author of *Acrylic Solutions: Exploring Mixed Media Layer by Layer*, and her recent work has garnered accolades at numerous San Diego Art Institute juried exhibitions. Julie lives with her family in San Diego, California.

LAYERED AND BRAYERED COLOR

It's time to create a timeworn finish with muted and layered color. This technique can be used on a variety of surfaces but works best on a smooth surface. Try variations including collage, transfers or other mark making on the raw surface before applying paint. Varying the paint formulations from Open Acrylics to fluids to heavy body paint will give you subtle textural variations.

MATERIALS LIST

assorted paints: Carbon Black, Cobalt Blue, Iridescent Stainless Steel, Neutral Gray N5, Teal

brayer

brush

bubble wrap

deli sheet

mark-making tool

palette paper or acrylic plate

spray bottle of water

stamp

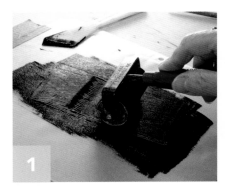

1

Brayer a layer of slow-drying Open Carbon Black paint onto a clean, flat surface such as a palette paper or acrylic plate.

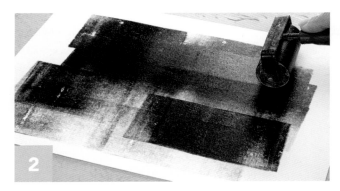

2

Apply the brayer with paint onto the panel in deliberately uneven strokes, allowing the white surface to show through in places.

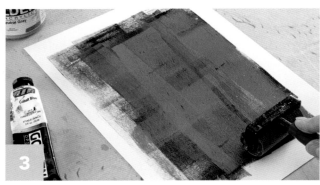

3

Create a mixture of Cobalt Blue and Neutral Gray N5 and roll it out onto a clean flat surface. Repeat steps 1 and 2 with the mixture, applying it on top of the black surface and allow some of the black layer to show through.

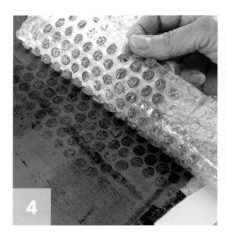

4

Press a piece of bubble wrap into the wet surface to create a pattern.

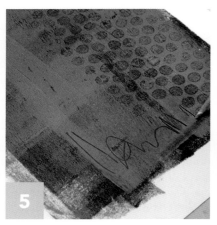

5

Use a pointed object to scratch into the top layer of paint.

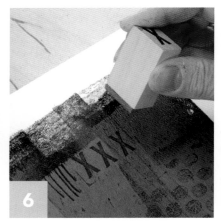

6

Stamp into the surface of the gray mixture with a nonfigurative rubber stamp, then let it dry.

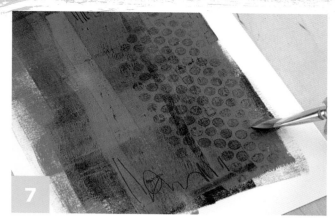

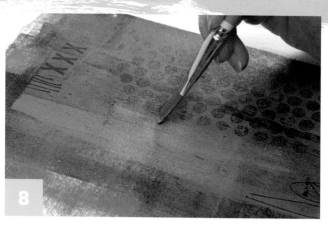

7 Mix a couple of drops of Teal into the remaining gray paint on the brayer sheet. Use a brush to apply the mixture to random areas on the surface of the painting using straight up-and-down strokes. Let it air dry.

8 Apply Iridescent Stainless Steel fluid paint with a brush to add a textural dimension to the painting.

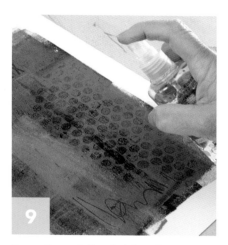

9 Spray the painting lightly with water.

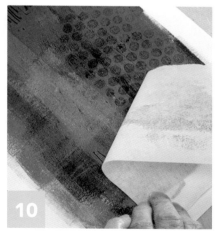

10 Use a deli sheet to lift up some of the paint and water from the painting's surface to reveal the underpainting. Scratch additional marks or words into the surface and let it dry thoroughly.

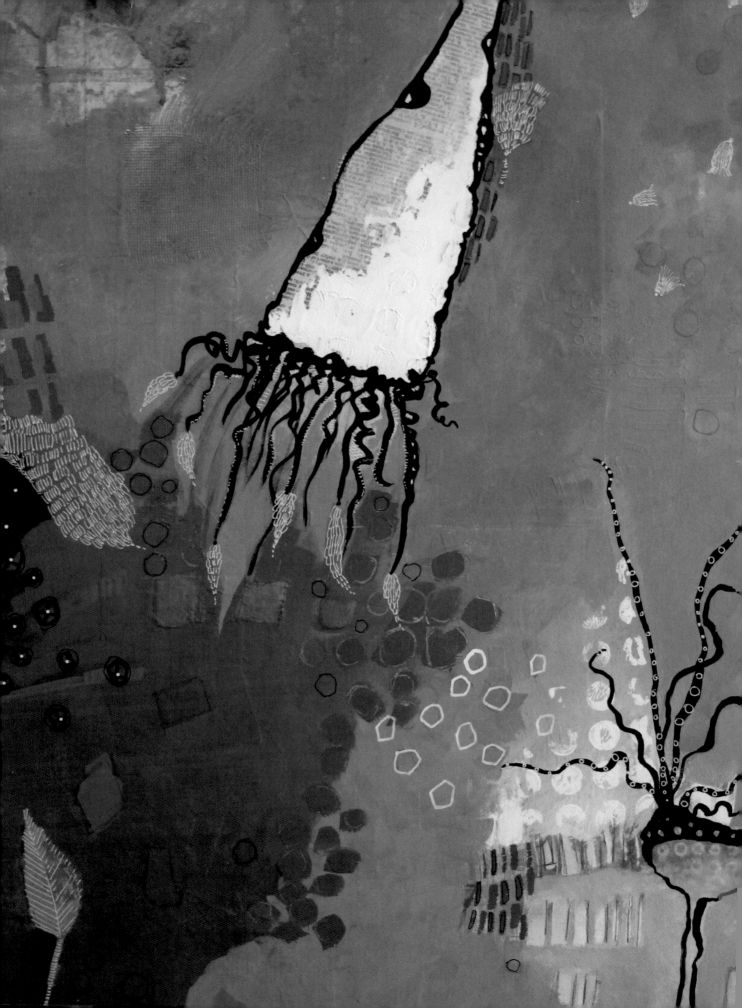

TONE DOWN THE COLOR

When you mix or apply color that is just a bit too strong or too bright, there is a quick and easy way to bring down the intensity or dull it using either Payne's Gray or Ultramarine Blue. Take a look at the difference adding a bit of these pigments can make to a color that is a bit too bright. This is one trick that will prove its worth very quickly with daily practice.

MATERIALS LIST

assorted paints: Payne's Gray, Phthalo Blue, Phthalo Green, Pyrrole Red, Ultramarine Blue

brush

paper

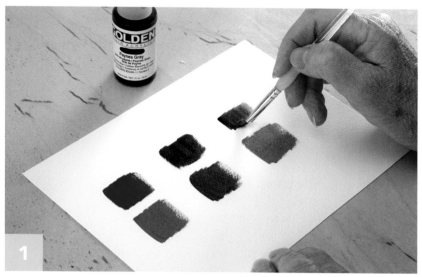

Apply Pyrrole Red, Phthalo Blue and Phthalo Green to your surface. Mix Payne's Gray into these colors to dull down the brightness of the paint.

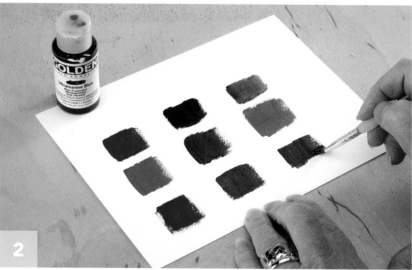

Mix Ultramarine Blue into the colors from step 1 to dull down the brightness of the paint. Compare the range of colors and note the difference in chroma.

WHATCHAMADOODLES
Chris Cozen
Mixed media, acrylic and ink on watercolor board
20" × 16" (51cm × 41cm)
Grays of various tones and colors are worked into the background, which creates a perfect foil for these whimsical shapes and markings.

3 spinning *the* COLOR WHEEL

The world of color is an exciting adventure for us to experience. Understanding the mechanics of the color wheel and the relationships of the colors to each other on the wheel will help us process how we view and make art.

The original color wheel was based on the spectrum of colors from light. Since we paint with pigments and every pigment has its own sensibility and set of behaviors, it makes sense that we should explore color wheels created from different pigment combinations. What would the signature color wheels of the painters from the past look like if they used the pigments available to them today? How did the pigments they used influence their color mixing? How will the pigments we use today translate to the color wheel?

Let's spin the color wheel and see where it takes us.

Check out artistsnetwork.com for free demonstrations and extra content.

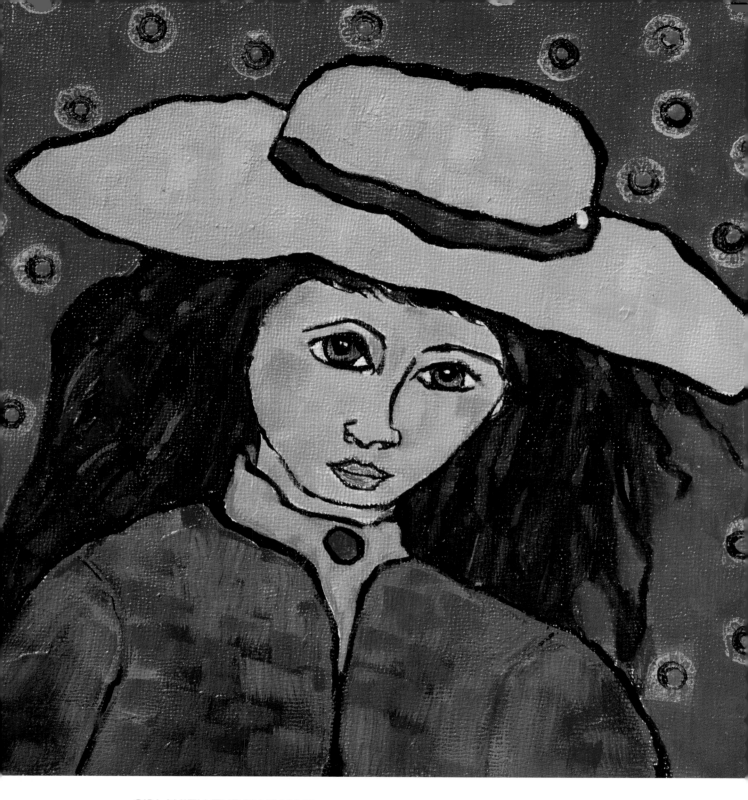

GIRL WITH THE BLUE HAIR

Chris Cozen
Acrylic on cradleboard
12" × 12" (30cm × 30cm)
The interior spaces of large areas of strong, bold colors are broken up
with many variations of color and pattern. Note how the aqua blue
color is repeated not only in the face and shirt but also in the pattern of
the background. Repeating colors helps to create visual cohesion.

A MODERN APPROACH TO A SIGNATURE PALETTE

Today we have a plethora of beautiful pigments created in the chemistry lab. These pigments are ideal for creating clear, crisp mixtures without a trace of mud, which is why I think of Henri Matisse whenever I use this color wheel (below).

Matisse started out as an Impressionist and was later involved in a movement known as Fauvism. He is best known for his use of pure colors, his enthusiasm for high-intensity contrasts and his abstract line work. Matisse pushed the boundaries of the art being created during his time and moved into modernism at the end of his life when he was too sick to stand at an easel. Through everything, Matisse remained exuberant and unafraid, creating an entire body of work based on paper cutouts in his final years.

COLOR CHALLENGE
Make a color wheel with one of these triads and compare the range of colors to a few of Matisse's paintings.

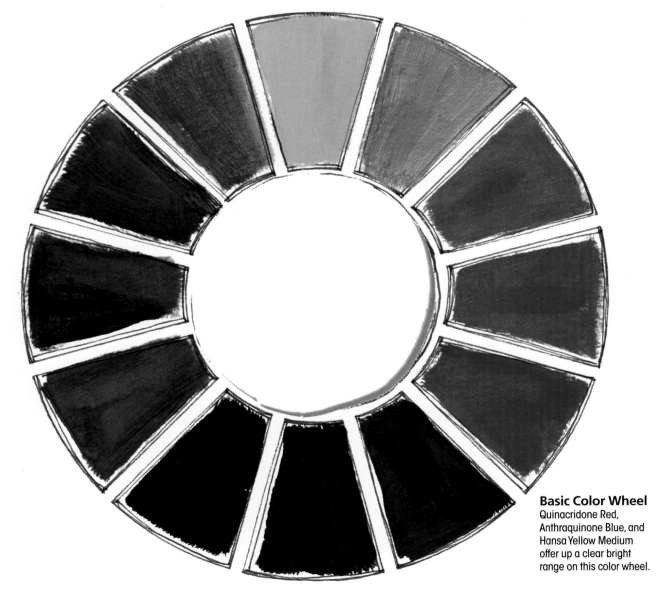

Basic Color Wheel
Quinacridone Red, Anthraquinone Blue, and Hansa Yellow Medium offer up a clear bright range on this color wheel.

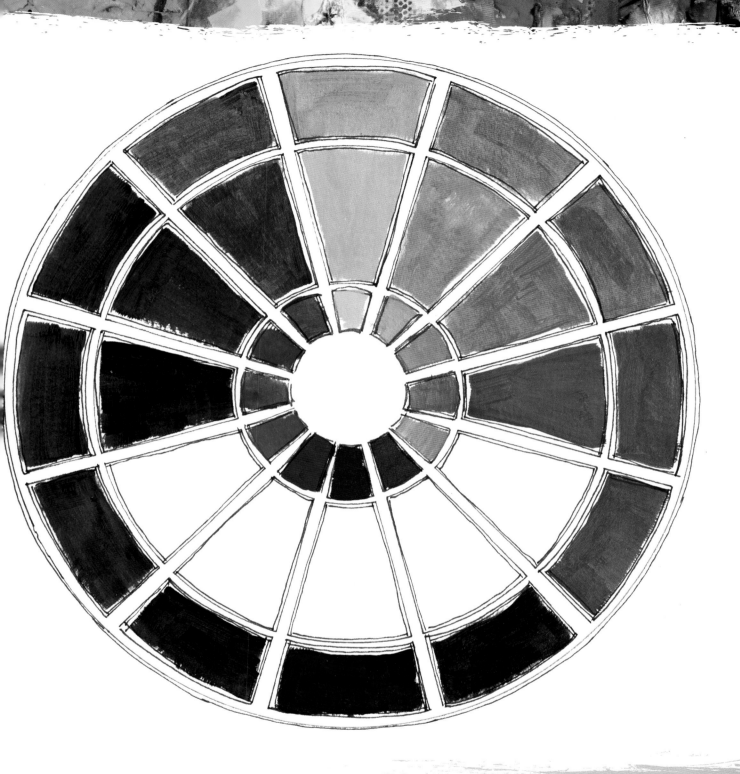

Matisse Color Wheel
In this color wheel the outer ring is made up of Nickel Azo Yellow, Quinacridone Magenta, and Phthalo Blue (GS). The yellow pigment is changed in the second ring to Hansa Yellow Medium. Note the influence on the Orange through green colors as a result. Changing just one color in your color wheel can lend a distinct shift to your work. The innermost ring notes the addition of white to each of the colors in the wheel.

COLOR MIXING
when mixing colors, always add your darker color to your lighter color and your opaque color to your transparent color. This will give you more control over the resulting mixtures.

COLOR TEMPERATURES

Pigments are biased. They have an opinion about how they are to be perceived by your eyes. Some blues lean more towards red, some reds are warm and they lean towards yellow, while other reds are biased towards blue. Reds that are biased towards blue, for example, will have a violet cast to them and will mix clean purples. Whereas reds biased towards yellow will read more orange. The temperature of a pigment influences all the other colors mixed from it.

Warm	Cool
Naphthol Red	Quinacridone Magenta
Cadmium Red	Alizarin Crimson
Hansa Yellow Medium	Hansa Yellow Light
Cadmium Yellow	Bismuth Vanadate Yellow
Ultramarine Blue	Phthalo Blue (Red Shade)
Anthraquinone/Indanthrone Blue	Cerulean Blue Chromium
Cobalt Blue	Cobalt Blue

NEUTRAL COLORS

Cobalt blue is considered a neutral blue and can be used in either category. It is a natural pigment and has semi-opaque qualities that influences the clarity of the color mixtures in which it is used.

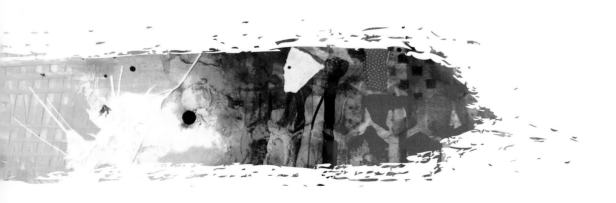

RAISING AND LOWERING THE TEMPERATURE OF COLOR

Pigments are expensive, so it is good to know how to make the most of each color you have. This exercise demonstrates how to change the color temperature of a single pigment.

MATERIALS LIST

assorted paints: Hansa Yellow, Pyrrole Red, Sap Green Hue, Titanium White

brush

paper

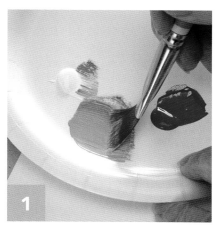

1 Add a few drops of Pyrrole Red and Titanium White to your mixing surface, then paint a stroke of red onto the paper.

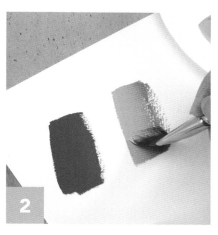

2 Mix more Titanium White with the Pyrrole Red to create a pink color. Paint a stroke of the new mixture onto the paper.

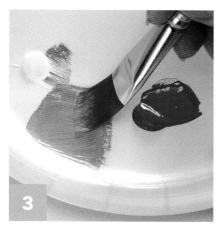

3 Add Hansa Yellow to the pink mixture to create a warmer orange color.

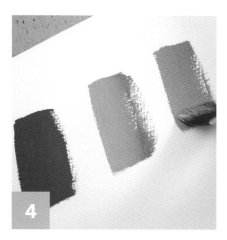

4 Paint a stroke of the orange mixture next to the other mixtures for comparison.

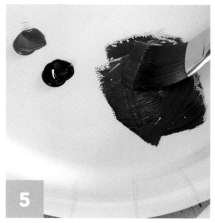

5 Mix Sap Green Hue with Pyrrole Red to cool it down and create a darker color.

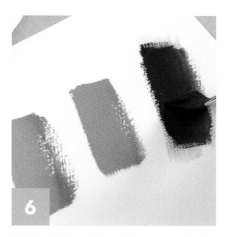

6 Paint a stroke of the darker red onto the paper for comparison.

COLOR CHALLENGE

shift a cool red (quinacridone) into a warm red by adding yellow. The key is to add a warm yellow. check the list to determine which of the yellows is warm.

Construct a Complex Monochromatic Palette

Expanding on the concept of working within a narrow mono-chromatic palette, this technique for building colors adds a second hue to the mix. For example, if you want to create a simple monochromatic palette using blue, then select a single blue hue whether it be Cobalt, Ultramarine, Anthraquinone, Phthalo, Cerulean or Prussian. Along with your choice of blue, you need a white and a black to create the palette. For the com-plex monochromatic palette you will add a second blue hue of your choice, black, white and orange (the complement of blue).

In this chart I want to demonstrate how a monochromatic palette can be expanded by adding in the complementary color. I have started with Phthalo Green YS and then will intro-duce its complement Pyrrole Red plus Black and White. Note how the intensity of the original color is significantly softened with the white, deepened with the black and gray, and then becomes more versatile with the addition of the red to the mix. The full range includes greater depth of color than could be achieved with just black and white.

COLOR CHALLENGE
start mixing once you've selected your hues.

Phthalo Green tone on one end and with glazing liquid on the other end.	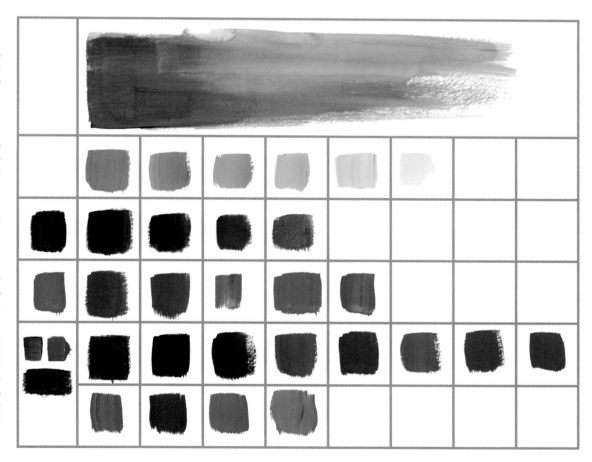	
Titanium White is added to the Phthalo Green in a range of tints.		
Bone Black is added to the Phthalo Green.		
Neutral gray mixture of black and white is added to the green		
Phthalo Green and Pyrrole Red are mixed to create a neutral and that is added to the various mixtures already created. Note the range of grayed tones possible.		

Demonstration
MOTHER COLOR

To ensure that your entire composition is visually cohesive consider using a blended color as an additive to your selected pigments. Adding an equal amount of this "new" color to each of your original pigments will keep all the color you create from them in agreement.

MATERIALS LIST

assorted paints: Cerulean Blue Deep, Hansa Yellow Opaque, Naphthol Red Medium

brush

paper

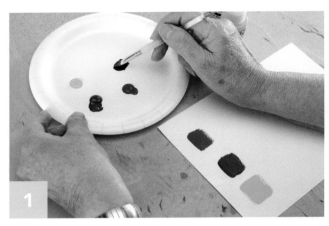

Apply red, blue and yellow paint to the mixing surface. Paint a swatch of each color on a piece of paper.

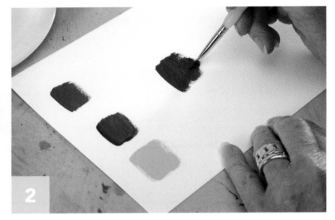

Gradually mix all three of the colors together to create a separate neutral mother color. Paint a swatch on the paper.

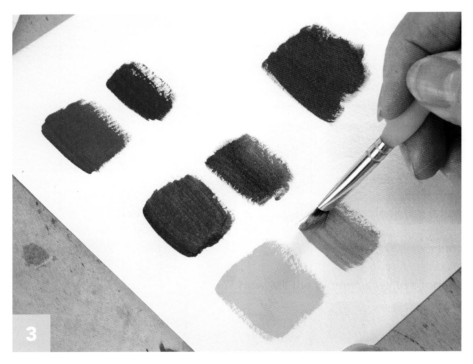

Add a small amount of the mother color to each of the red, blue and yellow colors and observe the color shift.

COLOR CHALLENGE

Follow the formula to mix a neutral color and add the new neutral color to one of the colors in the triad. Observe the change. Tint the new color out with white and then create shades with black. Compare it to a tinted out version of the original color and create your own storyboard for future reference so you don't have to try to remember what you mixed!

USING A MOTHER COLOR FOR UNIFYING

I ran across the concept of a *mother color* as I was doing research for this book. It is a unique way to create a palette of colors in which each color is intimately connected to every other. This is accomplished by mixing another color to each color of a triad to synchronize them, and there are only two ways to accomplish this.

The first way is to select a unifying color such as Payne's Gray and add a small amount of it to each of the triad colors before proceeding to create the color wheel. This will act as the mother color. Once the color wheel has been adjusted, you can proceed to paint as usual. By adding Payne's Gray, all of the colors used in the composition are now in visual agreement.

The second way to create a mother color is to create a neutral color by mixing all of the colors of the triad. Do this by taking an equal amount of red and blue then adding a double amount of yellow. Mix these colors into a neutral color. Proceed to add a bit of this neutral color back into the red, blue and yellow paints to create your color wheel. Remember that the mother color will be different for each triad you use.

With the addition of white, buff or black to these wheels you will have a full range of color options from which to choose.

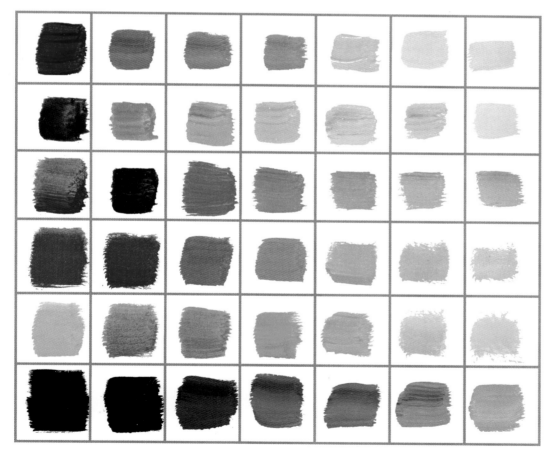

Creating a storyboard for color is an excellent way for you to analyze the influence small changes can make to your overall palette. In this chart I have recorded a few elements. The first column notes the neutral mother color created from mixing the triad of blue, red and yellow together. Continue with Payne's Gray, Cobalt Blue, Naphthol Red, Hansa Yellow and Carbon Black. In column two you see the influence of the Mother Color upon each of the original colors, the subsequent columns show tints of that shifted color. Row one across the top is the mother color made in the demonstration tinted out with white.

chris MEYER

Until now the discussion on color use has been primarily focused on paint applications, but now our understandings of color that came from learning to mix and apply a range of paints in a monochromatic or analogous range can also be put to use in the mixed-media world.

When we translate color to the selection of papers, objects and elements for collage, we need to apply some of the same skills as when we paint—and ask similar questions, such as: Can we discern when a yellow piece of paper has a color bias? Can we sort papers into shades, tints and tones? Can we "read" color well enough to make color choices in our mixed-media work?

Chris Meyer is an unique artist who works almost exclusively with a mixed-media color scheme that he sources directly from stones he finds and images he captures on camera while hiking in the mountains near Santa Fe

and Albuquerque, New Mexico. I met Chris years ago at an experimental art group where I was lecturing, and he's a pretty creative guy—he's a motion graphic artist, an author of books on the use of motion graphic programs and a musician.

Chris's work mixes close-up digital photographs of rock and stone formations with collage, text, paint and assemblage to create a layered piece that visually melds all of the layers. By staying within the natural color range of the elements that he captures on film, Chris is able to infuse a sense of harmony and serenity into his work. He tells me that he relies on "the contrast in value and shape" to bring his compositions into line and "striving to make more effective use of value" is something that Chris continually works towards.

When Chris speaks of value he is referring to the areas of light and dark

throughout his work. These values serve the purpose of creating balance within a composition. Too much darkness on one side of a composition will make it feel heavy and unbalanced, whereas an overly light composition can feel as if it's ungrounded and without substance.

Developing your eye for changes in color value is an important skill. I compare it to being able to interpret the nuances in someone's voice as you listen to the person read aloud. A reader with a flat monotone will be far less interesting than one who uses inflection, expression and modulation in his or her voice.

ENTRADA
Chris Meyer
Mixed media on cradled panel
20" × 16" (51cm × 41cm)
According to Chris Meyer, he "coined the term *Meyograph*—inspired by Rufino Tamayo's *Mixographs*—to describe the combination of photography and collage that my work is based on." These elements "introduce a degree of texture and underlying mystery in a way not often seen in either photography or painting."

ABOUT
CHRIS MEYER

Chris Meyer is a man of many mediums. In the 1980s he worked in the music industry designing synthesizers, samplers and digital audio recorders. In the 1990s he and his wife migrated to the motion graphic world with their award-winning studio Crish Design (formerly Cybermotion) from which they produced many well-known motion graphics manuals using After Effects. More recently Chris has turned his attention to creating mixed-media art. Chris has exhibited with many groups including Collage Artists of America, Los Angeles Experimental Artists and the Society of Layerists in Multimedia. He currently lives in New Mexico, which has become the inspiration of much for his most recent work.

MUDDLING ABOUT MIXING BROWNS

I was inspired by the color of Chris Meyer's natural palette and wanted to explore the whole idea of mixing and working with browns. I find preformulated brown pigments limiting. They just cannot give me the perfect brown I need for a specific color situation I may encounter.

After playing with some mixtures, here is what I have discovered: You can mix the perfect brown for any red-blue-yellow triad by using those same pigments to make the brown. Since the brown is mixed from the colors selected for the color wheel, it will be totally in sync with the entire wheel. Once again we encounter the perfect neutral. Use this neutral brown to adjust the chroma of the colors within the composition as we did with the mother color process.

Start with a triad and mix a secondary orange from the yellow and red. Add small amounts of the orange to the blue until you get the perfect brown to work with the palette. Add Carbon Black or Titanium White to tweak the brown for a lighter or darker effect.

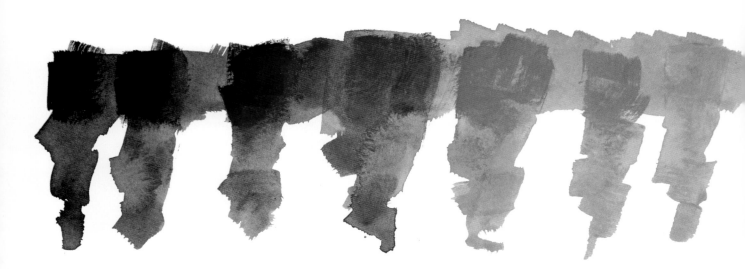

The swatch in the center line is a neutral brown mixed from Pyrrole Red Dark, Bismuth Vanadate Yellow and Manganese Blue Hue, which are modern pigment substitutes for Cadmium Red, Cadmium Yellow and Manganese Blue. The left side shows the influence of the introduction of Carbon Black to the neutral brown while the right shows the influence of Titanium White.

PERCEIVING VALUES

Every composition has a range of values from the lightest color to the darkest. Without a range of values, our eyes don't know where to go when looking at a piece of art. We can't discern what is important versus what isn't. Imagine being out in a fog and trying to find your way through it. When a light color is placed adjacent to one that is only slightly darker, there is very little shift in value.

On the other hand, placing white against black creates a strong contrast in values that is exciting to the eye. Immediately this area is identified as a focal point. One of the most important functions of value is to indicate the source of light. Utilizing a range of values also conveys texture, depth and dimension in your compositions. Values can be assigned to colors within a composition, but value itself is not about color specifically.

Learning to determine the values of colors applies to the selection and use of collage elements as well. It is an important skill as it speaks to the subtlety of a color's voice. Here is an exercise in arranging papers that will test our ability to perceive value shifts in mixed-media applications.

MATERIALS LIST
assorted papers

EN GRISAILLE

En grisaille refers to a painting that is done entirely in values of either gray or another neutral without any other color. This was done as a sketch or underpainting to check the values of a composition.

Find an assortment of found, scrap and deli papers.

Sort your papers in order of values from darkest to lightest.

COLOR CHALLENGE

Select some of your own papers and give this process a try. When I first started doing this, I usually ended up with more than nine values. How many can you find?

CREATE MIXED-MEDIA PAPERS WITH A GELLI ARTS® GEL PRINTING PLATE

Use a Gelli plate to create papers from colors you have prepared using the value scale. This way you will always have the right paper available to use and it will always be unique.

MATERIALS LIST

assorted paints: Mars Yellow, Quinacridone Nickel Azo Gold, Titan Buff

brayer

deli paper

Gelli plate

rubber scraper

stamp

stencils

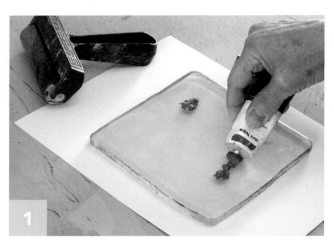

Squeeze out a small amount of Mars Yellow acrylic onto the plate.

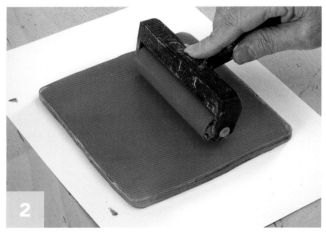

Brayer over the paint so that it's evenly distributed on the surface.

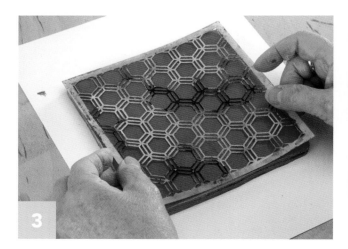

Place a stencil over the Gelli plate.

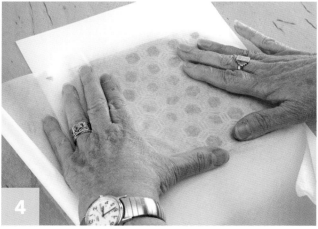

Place a piece of deli paper over the stencil and Gelli plate and rub your hand over the surface to print the stencil pattern onto the paper.

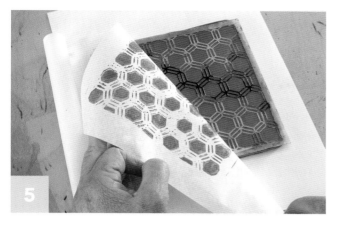

Pull the paper off the surface to reveal the print.

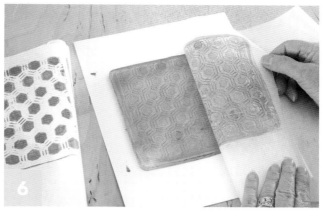

Remove the stencil and place a second paper over the plate. Lift a second (reverse) print off the plate.

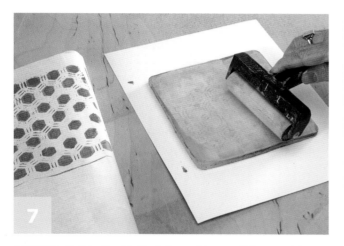

Add Titan Buff to the Gelli plate and brayer it thoroughly.

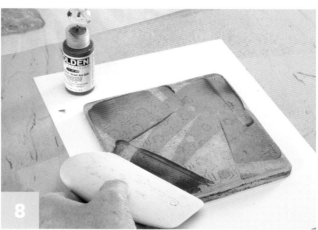

Add Quinacridone Nickel Azo Gold to the Gelli plate with a rubber scraper. Apply it in a random pattern.

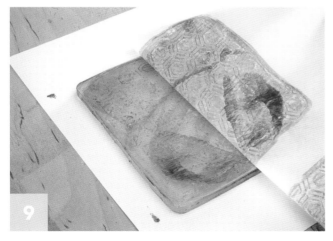

Lift the final print.

REUSE

Be frugal. Pigments are expensive. Transfer unused paint from your brush or brayer to dry-waxed papers. It maximizes your use of the paint, keeps your water cleaner and creates instant collage papers for future use.

WARM AND COOL ANALOGOUS COMBINATIONS

I love listening to a trio or a quartet harmonizing together. It's so beautiful the way the voices meld and complement each other. On the color wheel there are colors that will harmonize perfectly as well.

As you look at a color wheel, you'll see how all the colors travel in a circle around the outside. If you select any three or four that are adjacent to each other, then you'll find an analogous range that will always work together in any composition.

When working within an analogous palette, it's important to watch your values. Remember that value refers to the lightness or darkness of your color. Be aware that a contrast of values brings your work to life and creates movement. When all the colors are of the same value, it's difficult to discern what is important to see. Use black, white and gray to add to your colors or as stand-alone accents to expand the range of useable colors. With your skills in making tints, tones and shades, and creating chromatic grays, you are more than well equipped to create a composition that will be harmonious and pleasing—at least from a color perspective.

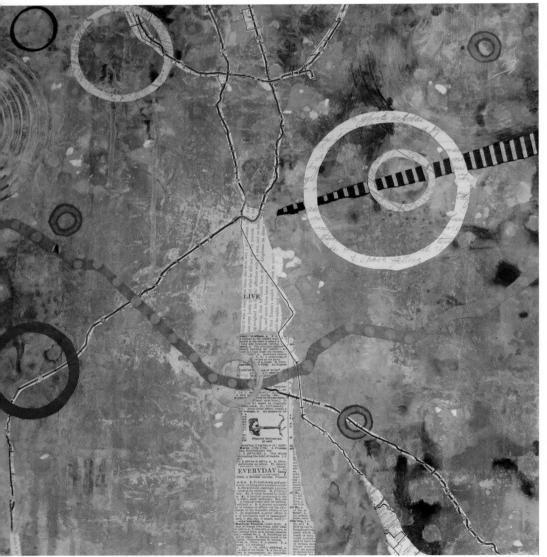

THE ROADS WE TRAVELED

Chris Cozen
Mixed media on canvas
18" × 18" (46cm × 46cm)
This analogous composition builds on the range of colors of yellow-green through blue-green on the color wheel. With the addition of Titan Buff paint and paper elements, this active composition balances the bright and soft tones of these compatible colors and takes advantage of the full range of values possible. The collage elements also add movement and focus to the composition.

CASTELLO ROSA

Chris Cozen
Acrylic and mixed media on hardboard
20" × 16" (51cm × 41cm)
This analogous painting is punctuated by bits of green to complement the purple background. The playful shapes utilize a full range of colors in the red and purple family. The light, playful tones convey a whimsical mood in keeping with the subject matter. A neutral gray was added to the colors in the palette to create more nuance.

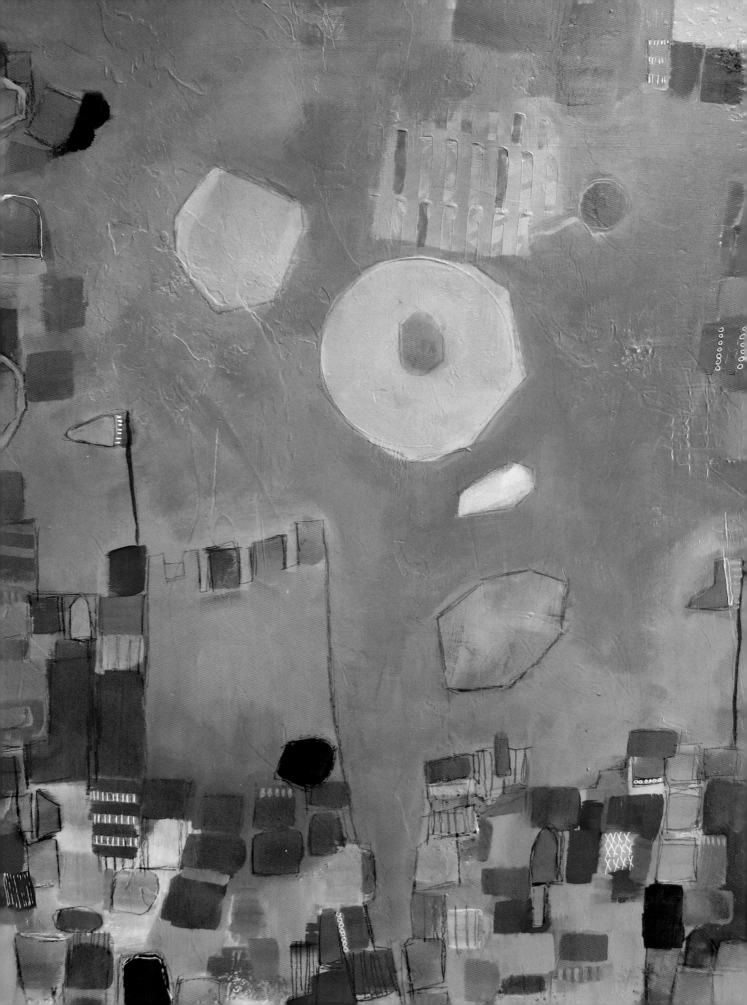

SURFACE MIXING AN ANALOGOUS BACKGROUND

By mixing colors directly on the surface you can develop an organic, free-form background that takes advantage of the development of colors that occurs as you move between the paints of your choice. Since these analogous colors are all compatible, you're assured of an outcome that works every time.

SHAKE IT UP
For a better effect shake the High Flow Acrylics before using them.

MATERIALS LIST

Acrylic Glazing Liquid

assorted paints: Aureolin Hue Heavy Body, Hansa Yellow Medium, Naphthol Red Light, Naphthol Red Light High Flow, Red Oxide, Titanium White, Transparent Pyrrole Orange

brush

color wheel

palette knife

paper or other surface

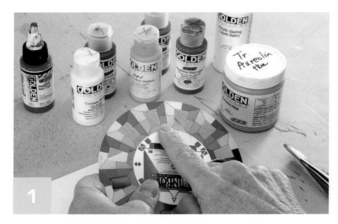

Use a color wheel to identify the analogous range of colors in the yellow to red-orange range.

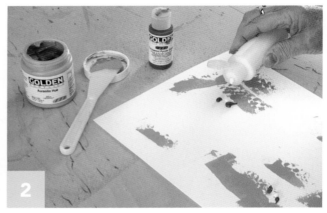

Use a palette knife to apply the Aureolin Hue Heavy Body paint to the surface. Then add drops of Transparent Pyrrole Orange and Titanium White across random areas of the paper.

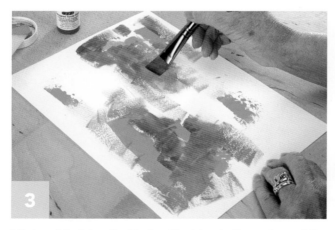

Mix in a bit of Acrylic Glazing Liquid onto the surface of the paper to help keep the paints moving easily.

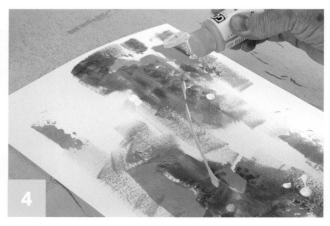

Add Titanium White and Hansa Yellow Medium onto the surface of the paper and mix them together.

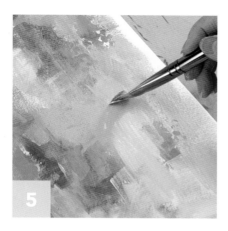

Continue mixing Titanium White and Hansa Yellow Medium onto the surface in random areas.

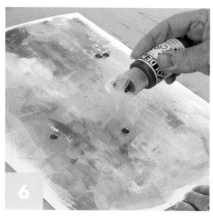

Add three to four drops of Red Oxide and Naphthol Red Light fluid acrylics onto the painting.

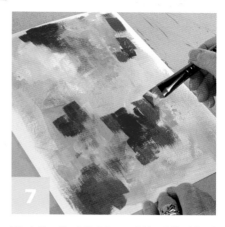

Work the Red Oxide and Naphthol Red Light fluid acrylics into areas across the surface.

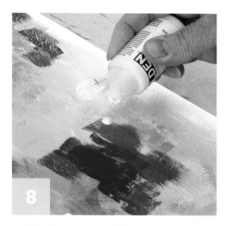

Add a few drops of Titanium White fluid acrylic onto the surface.

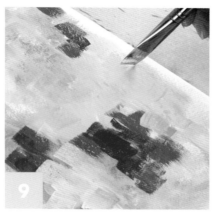

Mix the Titanium White in with the other colors to create lighter areas.

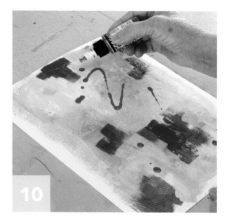

Squirt Naphthol Red Light High Flow acrylic or acrylic ink onto the surface in random patterns and let it dry.

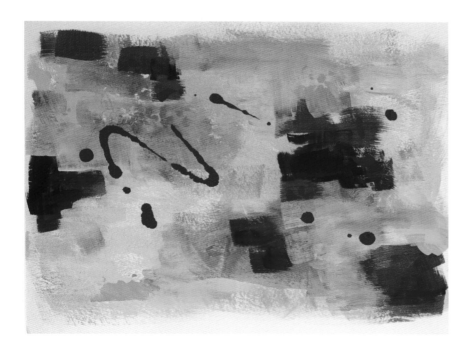

INTEGRATE YOUR COLOR

To create even more variations of color on your surface, don't clean your brush in between colors—let the colors mix.

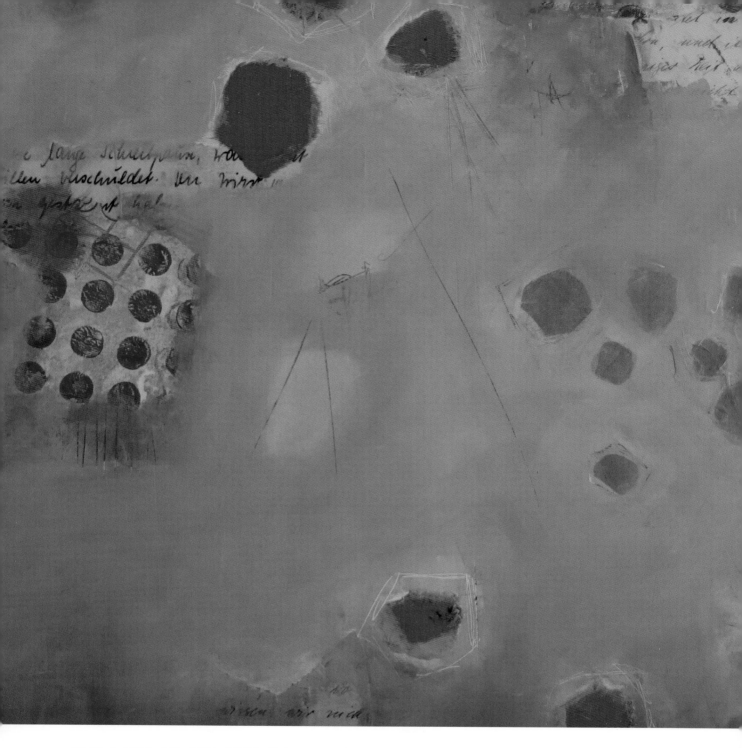

COMPLEMENTARY COLORS

Vincent van Gogh really understood the use of complements as most of his compositions placed blue and orange in juxtaposition to each other. He also used only pure color to create his work. It's this quality that distinguished him from his contemporaries.

Thus, van Gogh used color in a way that had not been done before. He interpreted what he saw and painted it in high-energy combinations and, although underappreciated during his lifetime, his dramatic use of color was the impetus for the development of the Fauvist movement, which took what van Gogh started and amplified it. This group of artists from the early twentieth century embraced van Gogh's

BITS AND BOBS
Chris Cozen
Acrylic and collage on board
12" × 12" (30cm × 30cm)

choices of pure color along with high-key complementary colors and painted in a strident and demanding manner. Shapes began to be abstracted into simpler forms and instead of contrasting tones they contrasted hues.

Complementary color combinations are all about getting noticed. You see them on team uniforms, logos and billboards. They're used heavily in advertisements and in design applications where the goal is to call attention to something. When you reach across the color wheel to the opposite side, you are choosing a color that will introduce a degree of tension into your composition. It's a bit like taking a position in a lively discussion.

Just as in arguments, your placement of complementary colors can be balanced, heavily dominated by one color or the other, or disintegrated into a cacophonous mess with no clear winner. It's always about balance and harmony when working with these strong-minded vocal colors. When you paint one complement adjacent to another, you create a "vibration" where each color seems to magnify the other.

However, be mindful when working with complements to keep from creating too much noise. Include some quiet areas within the composition to provide a rest for the viewer's eyes since too much vibration can be visually overwhelming. Make these colors really sing by using neutrals or mixed complements to create restful tones and quiet places within your work.

LILY PADS
Chris Cozen
Acrylic and collage on cradled wood board
20" × 16" (51cm × 41cm)
These two pieces use a variation of the blue and orange complement. Each of the twelve colors on the color wheel has a complement that can be found directly opposite from it. In these examples it is a blue-green and yellow-orange combination.
Note how one painting uses the yellow-orange as the dominant color while the other uses the blue-green as the dominant. Areas of neutral color help to provide balance in the landscape, while various tones on the dominant blue-green color calm the body of the *Lily Pads* composition, allowing the yellow-orange elements to come forward.

GOLDEN POND
Chris Cozen
Acrylic and mixed media on watercolor board
20" × 16" (51cm × 41cm)

UNTITLED

Chris Cozen
Acrylic on canvas
10" × 10" (25cm × 25cm)

Red commands your visual attention and pulls your eyes towards it. I wanted to keep the colors in this piece
limited due to its small size. The turquoise and green areas along with the black line impressions play beauti-
fully off the strength of the red background. I can easily visualize this small painting hanging at the end of a
hallway, beckoning me forward.

jenny DOH

Color is expressive. It can help us say what words cannot. Learning to draw out every nuance and intonation from color is a commitment every artist should make, whether it's through a subtle light shifting and quiet composition, a flamboyant expressive artwork filled with colorful gestures, or anywhere on the spectrum in between.

Becoming expressive with color is something our next artist has really invested in. I have enjoyed watching Jenny Doh transition from an advocate for artists during her years as editor in chief at Stampington, an art and craft-ing magazine publisher, where we first met, through her active blog presence and her hosting of artists at her own Studio CRESCEDOh in Santa Ana, California. Jenny has also authored numerous books on crafting, sewing and knitting. Recently she's been pursuing painting (or maybe painting has been pursuing her) and is sharing her process with others.

She begins almost every painting intuitively and this has served her work well. Jenny feels that "color expertise develops through direct experience." In other words, you need to get in there and use paint to learn about colors and how they blend together. Find out your "feelings about whether [you] like the end result or not."

The lesson we'll take from Jenny's work is to explore every layer, learn from every mistake and enjoy the process of discovery with every color.

UNTITLED
Jenny Doh
Acrylic on canvas
12" × 12" (30cm × 30cm)

ABOUT
JENNY DOH

Jenny Doh was born in Seoul, Korea and moved to Bakersfield, California in 1974. She is an author, active blogger and packager of numerous art and crafting books and is considered a leader in the world of art and craft publishing. Jenny lives in Santa Ana, California where she runs Studio CRESCENDOh where she teaches painting and fiber arts. The studio also hosts visiting artists who teach painting, mixed media, art journaling and more. Jenny consults on topics of publishing and creative development.

Demonstration
EXPRESSIVE PAINTING

Staring at a blank canvas can be intimidating. Expressive painting can help you jump in. Choose a few of your favorite colors and just start painting. Use this as an opportunity to learn what happens when you mix things up on the surface. With acrylics you can always paint over what you don't like. I picked up some wonderful new color mixtures using Jenny Doh's favorite palette.

MATERIALS LIST

assorted paints: Anthraquinone Blue, Fluorescent Pink High Flow, Graphite Gray, Naples Yellow Hue, Teal

brush

palette knife

panel

spray bottle

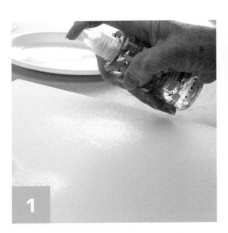

Lightly spray water onto the surface of the panel in a few places.

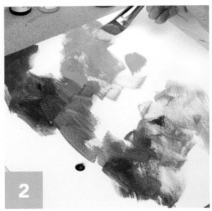

Randomly add drops of Naples Yellow Hue, Anthraquinone Blue and Teal onto the surface of the panel. Now begin painting, moving from one drop to the next, mixing the colors together.

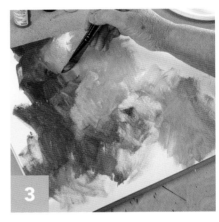

Continue going around your canvas using all the paint until your brush is completely dry.

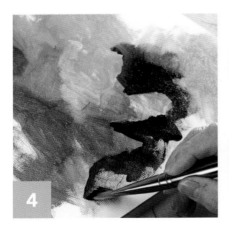

Add a few more drops of the Anthraquinone Blue onto the surface and paint it across the panel filling up white areas. Use the edge of your brush to cut into the other colors of the background, creating shapes.

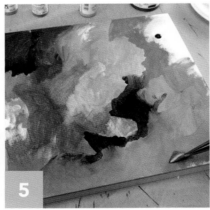

Add more drops of the various paint colors in random areas across the panel and fill up all the white space. Mix the colors with each other as you proceed.

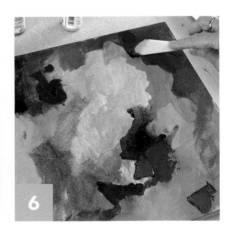

Use a palette knife to add some Graphite Gray to a few areas.

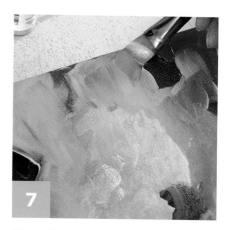

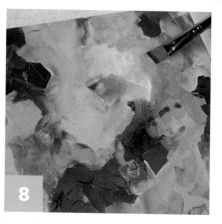

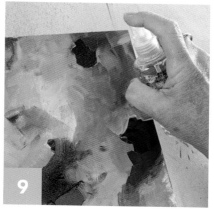

| 7 | 8 | 9 |

Clean the brush. Add Naples Yellow Hue around the Graphite Gray then blend the colors, leaving some of the gray shapes showing.

Drop Fluorescent Pink High Flow paint randomly across the panel and blend in the pink paint.

Spray water onto the pink areas of the panel to soften the edges of the paint. Let it dry then notice how it shows a complex range of pure color, tints, tones and mixtures.

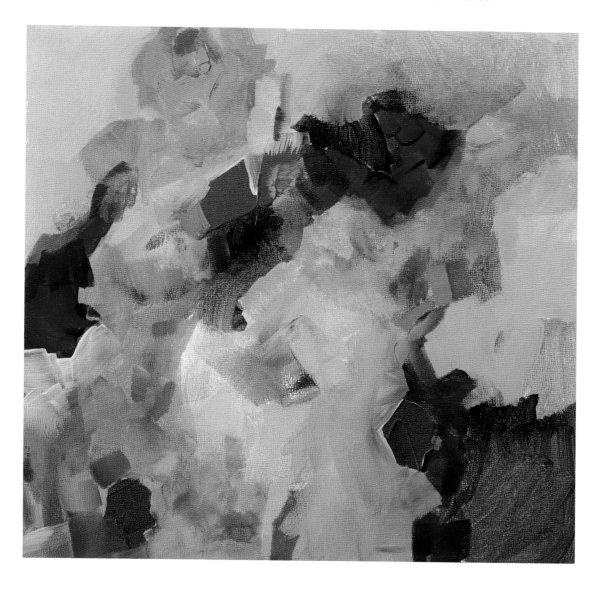

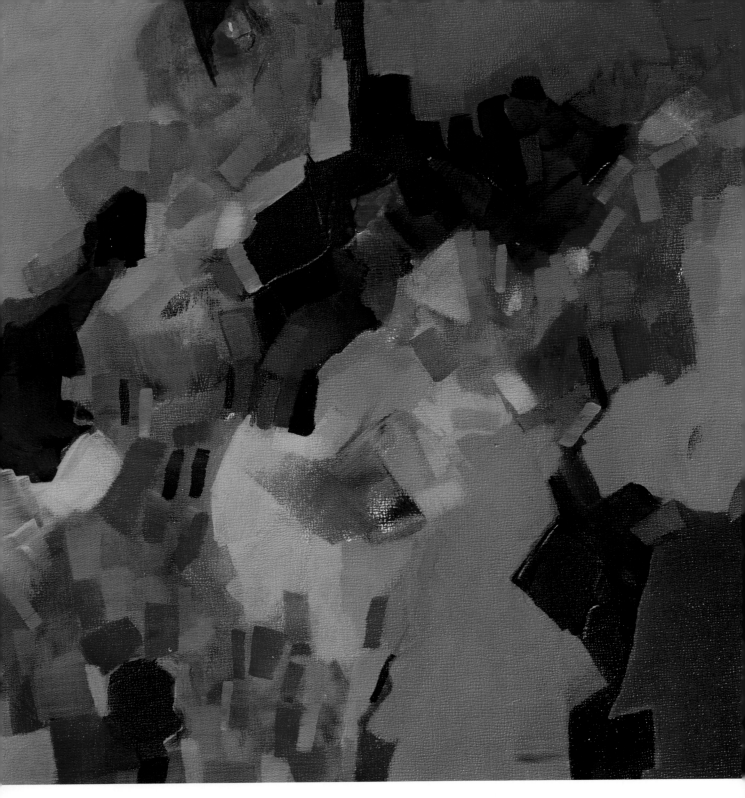

CHIPPING AWAY
Chris Cozen
Acrylic on board
12" × 12" (30cm × 30cm)
This painting began at the end of the Expressive Painting Lesson earlier in the book. It called out to me that there was more that needed to be done. I returned to add a simple chiseled brush stroke in many colors to the spaces that had be revealed earlier. It always fascinates me how colors combine to create conversations with us. I try to listen as often as I can.

Check out artistsnetwork.com for free demonstrations and extra content.

RANGE OF REDS

Everyone should paint with red at least once. Red is an amazing color with many personalities. Keeping in mind Jenny Doh's advice about getting in there and exploring color, let's explore what happens to various reds when we introduce some variations.

It is important to visually discern the variations that occur as the individual reds respond to the introduction of yellow, black or white. These small changes can bring great range to your color usage, providing you with more interesting blends and mixes.

MATERIALS LIST

A selection of Red paints(any formulation). Choose from Quinacridone Red, Pyrrole Red, Napthol Red Light, Red Oxide, Cadmium Red

Hansa Yellow Medium (or other yellow of your choice)

Titanium White

Bone Black

Create a simple box chart with sections across to list and show a swatch of all of the red colors you wish to adjust. The sections going down will list the white, black and yellow used for the adjustments.

> "If one says 'red'...and there are fifty people listening, it can be expected that there will be fifty reds in their minds. And one can be sure that all these reds will be very different."
> —Josef Albers

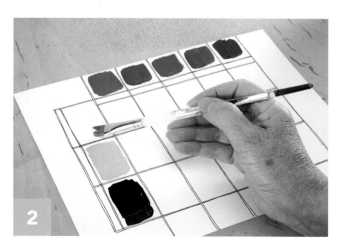

Fill in each of the top sections with your reds and each of the boxes going down with white, yellow and black.

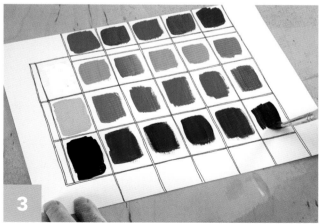

Proceed to mix each red into the yellow and insert a swatch of the color in the appropriate box. Repeat this process with the white and black. This is a useful way for you to record the interactions of color and be assured you can reproduce any red in the range with certainty.

THE PROCESS OF PAINTING

Let's pause for a moment and think about how we start the process of painting. Of course we select and prepare our surfaces properly so that we can be assured that our efforts will be successfully realized. But at this point the paths we take become divergent.

Many artists plot and plan, preparing small studies of the outcomes they are hoping to achieve. Others, like myself, prefer to approach a bare canvas in an intuitive manner. Some begin intuitively and then pause midway and begin planning. These are all workable approaches that lead to successful paintings.

Overall, this is a topic that bears exploring in the context of color. I find that my intuitive approach has often led me to discover things about color that I wouldn't have otherwise realized. Experimentation and exploration are valuable tools when working with color. I liken it to the beginning of a musical composition.

Notes flying about with some of them coming together to form snatches of a melody. The whole of the music is yet to be revealed to me, but I can begin to see what might develop.

> "you put down one color and it calls for an answer. you have to look at it like a melody." –Romare Bearden

Before I move on, I take the time to study the surface and look for the gems of music that are present. Sometimes the music does not work at all and I begin again.

There are times when much can be said on the surface of a painting by limiting oneself to a few selected colors. This is sometimes a challenge for me since I love color—a lot of colors. But on occasion, when all the stars align, the magic of a limited palette works for me and I am content.

In this section we will look at two ways to limit our palette. In the first, we will limit the number of colors we'll work with to three pigments plus black and white with the goal of using them to create as many colors as possible from which to work.

For the second, we will explore a soft pastel palette using three colors and buff. It will push us to explore the potential of a palette with very little color. The value in such an exercise is that it forces us to learn what is possible within a smaller range of color without the distraction of all the other colors out there begging for attention.

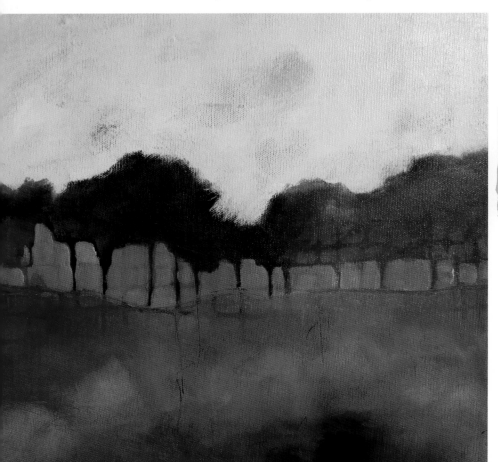

COLOR CHALLENGE

choose a triad of high–intensity colors plus black and white and create a color board. Discover just how many colors you can pull from so few pots of paint.

A SINGLE ROW OF TREES

Chris Cozen
Acrylic on canvas
12" × 12" (30cm × 30cm)

Demonstration
RELYING ON NUANCE

Once you've revealed your color story by creating a chart, you can proceed to develop a painting that uses a limited palette. I've chosen to create a simple garden window scene to demonstrate the process of coaxing out a wide range of colors.

MATERIALS LIST

assorted paints: Anthraquinone Blue, Bone Black, Indian Yellow Hue, Quinacridone Magenta, Titan Buff

baby wipes (unscented)

brush

makeup sponge

panel

paper

stencil

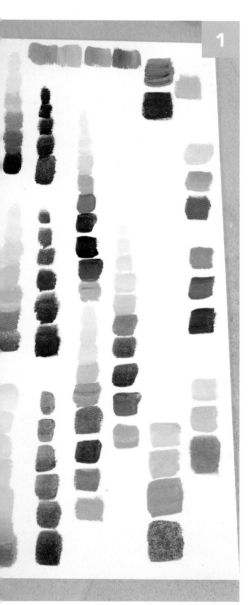

I always recommend that you create a color board to record the range of colors you'll create using the triad of a limited palette. Recall the lessons we have already covered. There are the tints made by adding white or buff as well as the range of shades created with Bone Black.

Create secondary colors mixed from the three primaries, and their tints and shades. Don't forget the tones that are possible when gray is mixed into all of the colors you have created, and that a neutral brown is easily created by taking one primary and mixing it with a secondary color.

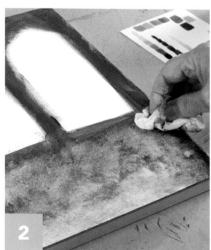

Create a neutral gray mixture of Quinacridone Magenta, Anthraquinone Blue, Indian Yellow Hue and a tiny bit of Titan Buff to make it less opaque. Then lay down a rough background using short, straight strokes leaving window-like areas free of paint. Then use a baby wipe to remove some of the paint from the lower section of the painting.

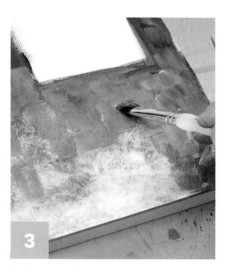

Add areas of lighter gray over the background in the lower half of the painting.

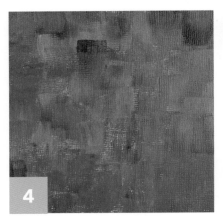

4 Create a variety of gray tones by increasing and decreasing the amount of Titan Buff and Bone Black in the mixes. Fill in the entire lower area with these colors.

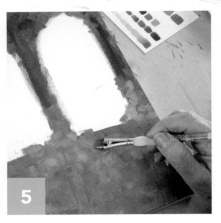

5 Mix Anthraquinone Blue and Indian Yellow Hue to create a green, then apply it in small, straight strokes to imply a leaflike pattern around the windows. Create color variations in the green by adding more Titan Buff and Indian Yellow to the original green.

6 Add a very small amount of the Anthraquinone Blue to Titan Buff to create a light blue. Fill in the entire areas of both windows. Use the same color to brush into the green to create a natural canopy over the windows.

7 Mix Quinacridone Magenta with Titan Buff to create a light pink to paint roses along the edges of the windows. Use a short, curved stroke applied in layers around an open center. Layer lighter pink over the darker pink to bring dimension to the roses and provide depth.

8 Using a mixture of Indian Yellow and Titan Buff, fill in the centers of the flowers.

9 Use a makeup sponge to apply Titan Buff paint over a stencil in the window areas of the painting.

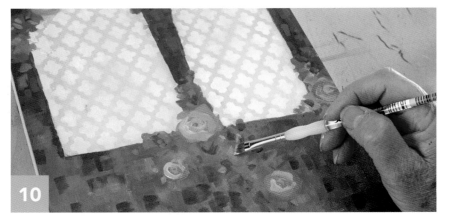

10 Mix a light yellow-green from Indian Yellow, Titan Buff and a small amount of Anthraquinone Blue. Apply on top of the green areas for highlights.

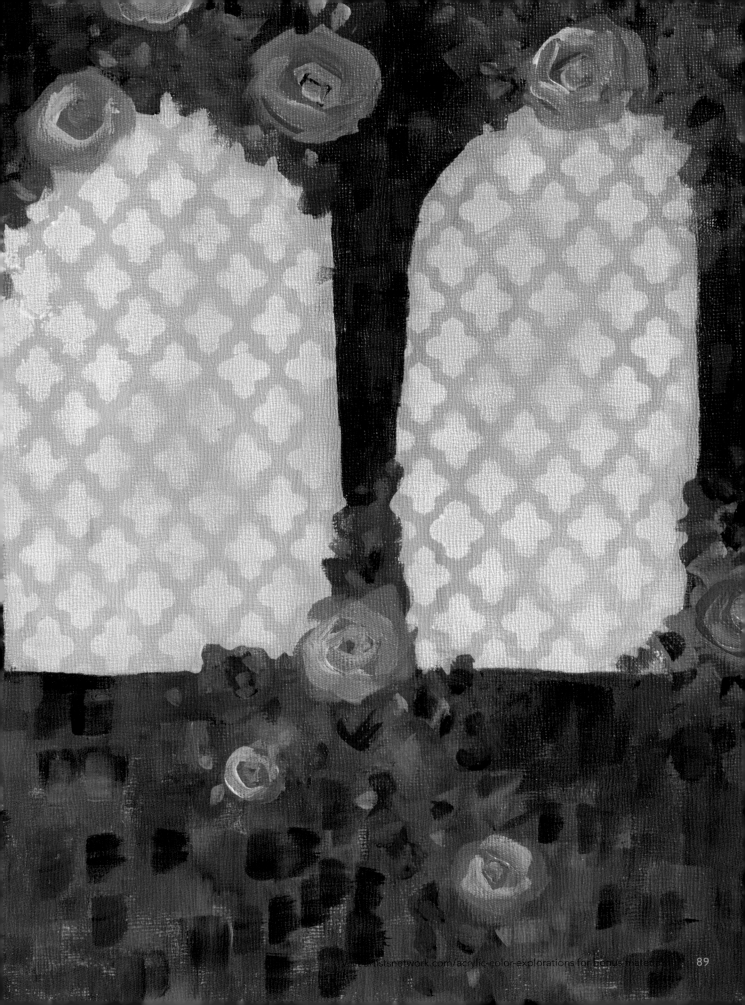

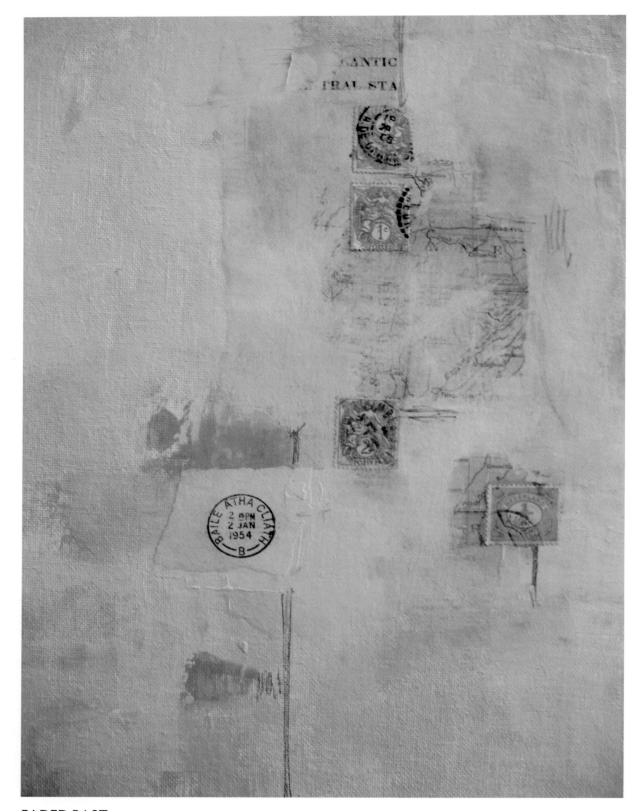

FADED PAST

Chris Cozen
Mixed media on canvas board
14" × 11" (36cm × 28cm)

When introducing collage elements into your compositions, it's critical to take into account the color context of those elements when developing your palette. In this piece the choices were vintage papers and elements conveying a timeworn aspect that needed to be played out in the overall composition. By creating a palette that appears faded by time, I was able to realize my intent.

FADED PAST

So much can be said with a quiet tone. Endearments, promises of love, secrets and soothing lullabies are but a few that come to mind. Utilizing a soft pastel palette can be one way to paint with a hushed voice. When you choose to work with colors that are very close in value there are some things that need to be considered. How will you develop contrast? What range of colors will you use?

I am of the "less is more" school of thought when it comes to approaching a palette. In mixed-media pieces, collage elements play a key role in the development of a color story within a composition. Consider the colors evident in the papers and ephemera you choose when selecting your paints.

MATERIALS LIST

assorted paints: Titan Buff, Sap Green Hue, Transparent Red Iron Oxide

brush

ephemera: maps, pages, vintage stamps

Fluid Matte Medium

palette knife

panel or paper

scissors

scratching tool

1

Select your collage elements. Apply Fluid Matte Medium to the surface of your panel and to the back of the collage pieces, then adhere them to the panel.

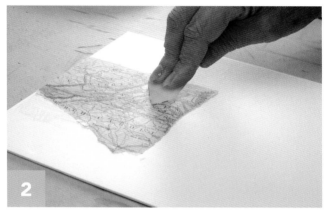

2

Use the flat edge of a wide palette knife to seal the collage elements to the surface of the panel. The excess medium will squeeze out and can be used to cover the top surface of the element.

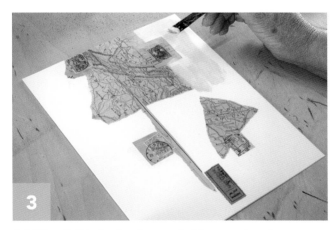

3

Add Titan Buff to the background of the panel and over some of the collage elements to soften the edges.

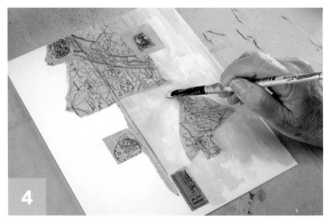

4

Tint the Titan Buff with a little bit of Sap Green Hue in areas where the collage elements have green incorporated into them. Use lighter and darker values of this mixture where necessary.

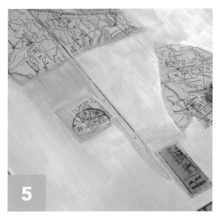

5

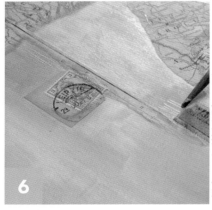

6

SCRATCH THAT

I prefer using open acrylics when scratching into the surface of paint.

Apply Transparent Red Iron Oxide in three areas, two on top and one on bottom. These highlights will guide your eyes along the canvas to where you want the viewer to look.

Make a few marks by scratching into the surface of the paint.

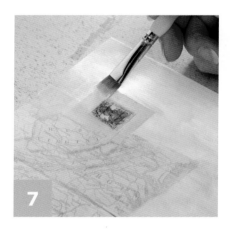

7

Go over the surface with a thin layer of Titan Buff to push back any areas that have gotten too strong and meld all of the timeworn layers together. Add any final touches and let it dry.

CREATING TINTS

The best color to use for creating tints with vintage ephemera is Titan Buff. Its linen-like color blends perfectly with old papers, instantly creating compatible tints.

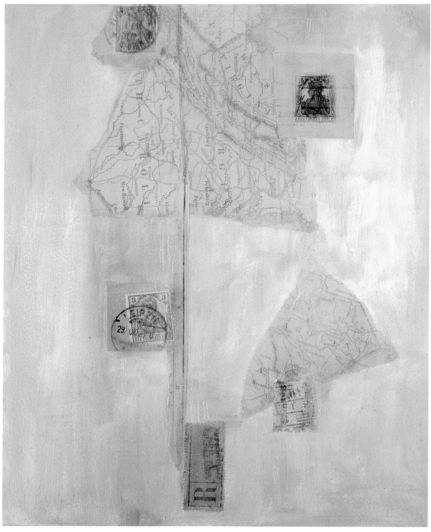

MODULATING YOUR COLOR VOICE

Finessing the fine transitions of subtle color can be a challenge. Whether it is done with sheer glazes, a soft neutral, a pastel palette or through the addition of sheer collage layers, it is an important skill to master.

There are times when the color you have applied proves to be too harsh, too dominant or just plain awful. What about those moments when you thought you had the perfect green that turned out way too blue?

I encourage you to seize upon these moments as opportunities to apply sheer layers of color to manipulate these mistakes into successes. Color adjustments can be made in so many unique ways.

Let's explore a few together.

1:10 1:5 1:3

Glazing Ratios

The first number refers to the amount of paint, the second refers to the amount of glazing medium. So 1 part paint to 10 parts glazing medium is a much more transparent glaze than one that has a 1:3 ratio. This means that less color will be visible when the layer is dry.

Sheer Glazes

There is no simpler and more efficient way to quickly and easily shift a color than through the application of either a transparent or a translucent sheer color glaze. There are several ways to create a glaze and all of them work.

You will need a medium that is either transparent or translucent to mix with your color. My preferred medium is Golden's Acrylic Glazing Liquid. This product has an added advantage in that the formula includes a bit of retarder that slows down the drying time and leaves more time to work with the glaze layer before it dries. With this product I can drybrush the surface I have glazed to virtually eliminate all the visible brushstrokes. Glazes can also be made using Polymer Medium (transparent) and Matte Medium (translucent). Glazes made with either of these products will dry at the same rate as the paint since they do not contain retarder.

Thicker layers of glazes can be made with gel medium, which comes in various viscosities (soft to extra heavy) and transparency levels (gloss, semigloss and matte). The ratio of paint to medium depends on how much of a color adjustment you wish to make.

SHEER ADJUSTMENTS WITH GLAZE

Adding sheer color layers over a painted surface can create either dramatic shifts or minor adjustments to the way the overall composition reads. The glaze layer influences each color on the painted surface uniquely.

MATERIALS LIST
paint: Phthalo Blue
palette knife
piece of art
Soft Gel (Matte)

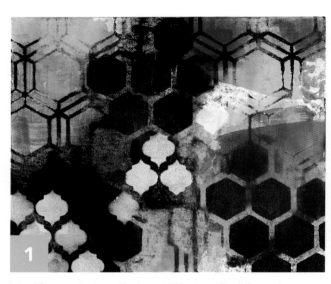

Identify an art piece that you'd like to adjust the colors.

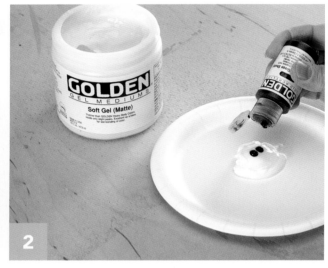

Add two drops of Phthalo Blue to one tablespoon (15ml) of Soft Gel (Matte). Mix well until there is no white showing in the gel.

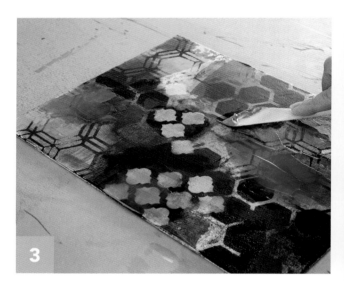

Use a palette knife or broad blade to apply the blue gel mixture over various areas of the surface. Let it dry.

Note how the glaze has affected the original colors painted on the surface, creating a purple where the color went over the pink as well as a green where the blue glaze went over the yellow.

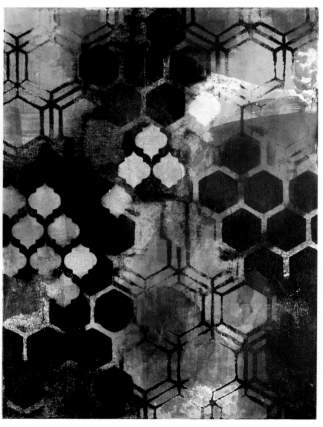

SHEER ADJUSTMENTS WITH PAPER LAYERS

There is another way you can create color variations over areas on a painting that does not involve paint. I always keep a stash of sheer, nonfading colored tissue and tissue-like Japanese papers such as Gampi, Unryushi, Mulberry and Lace Washi for just such a task.

By choosing a color variant from my tissues that works with my composition, and applying it with Polymer Medium or Matte Medium, I can selectively alter the way the color reads in my composition—area by area. With white tissues I can push an entire section back and rework it by adding an additional layer of the sheer glazing technique once the paper layer has dried. Gampi silk tissue is extremely sheer and sturdy and can take on any color you can imagine. I especially love using wet washes to create variations of color. When it's dry I can pick and choose the areas I want, tear or cut them out and apply them with medium. One last favorite sheer application is Origami Mesh. This is an open weave "fabric" designed for use in creating origami figures. The open weave creates the visual illusion of softening the color even though the fibers are opaque.

MATERIALS LIST

matte medium

Origami Mesh paper

painted panel

palette knife

various sheer papers of your
 choice to the materials list

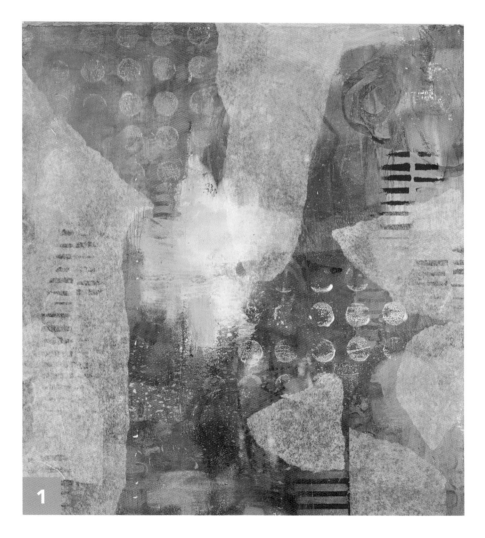

1 Find or create a painted panel to adhere the sheer papers to. This board was stenciled and painted. Pieces of sheer archival tissue have been added to the surface. You can see the influence of the tissue over the red stenciling on the left side.

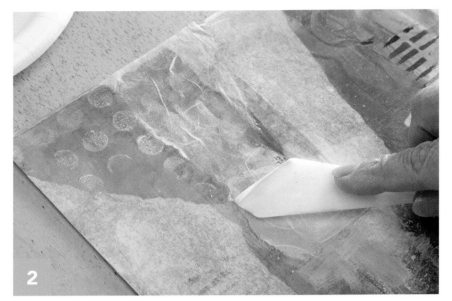

Once the papers have been placed, smooth over the papers with matte medium to seal them to the board. Use the flat edge of the blade to firmly go over each paper.

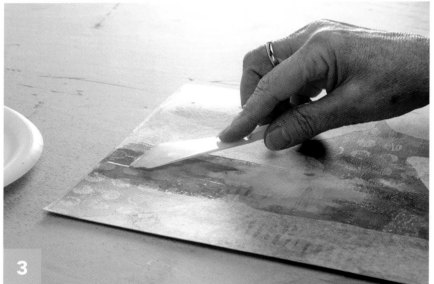

Apply matte medium to the panel with a palette knife in areas where you'd like the paper to be arranged.

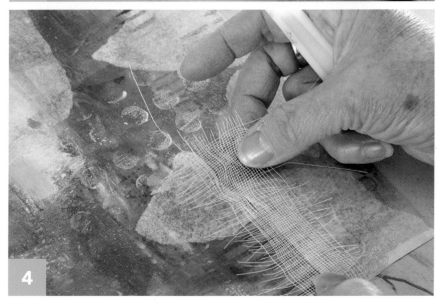

Tear the Origami Mesh and shred the threads. Attach the Origami Mesh in the same way as you did with the papers from step 2.

Finish attaching all of the papers and allow the panel to dry. The various sheer papers will create interesting spaces and shapes, and the origami mesh will provide movement and texture.

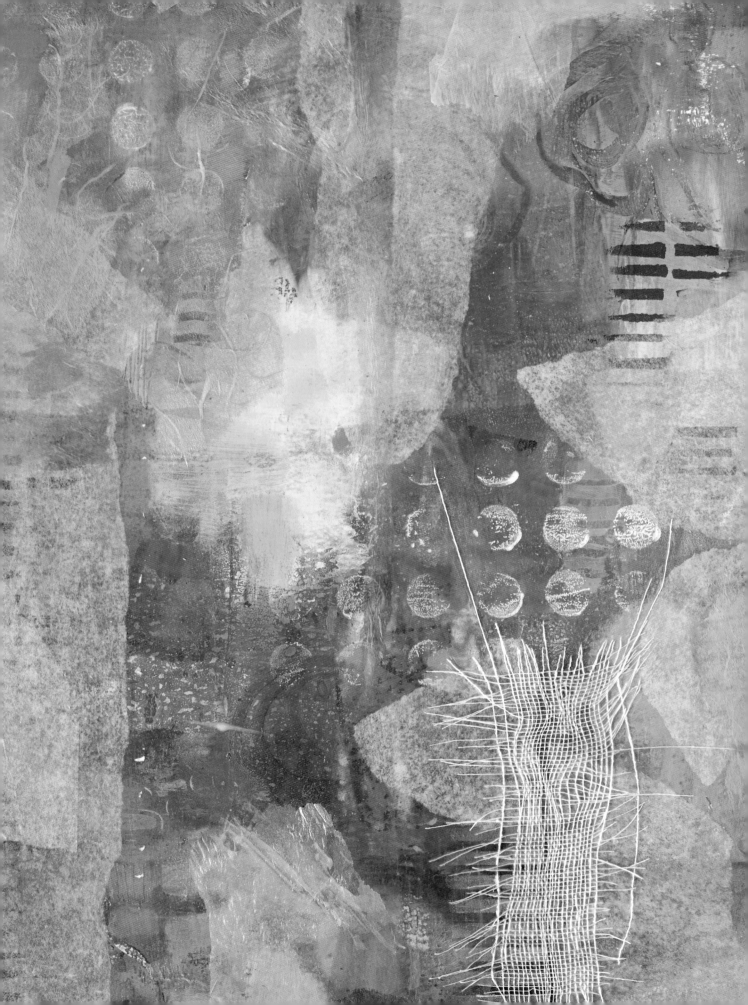

Making Magic Specialty Paints and Glazes

There are paints available that let you play with light. Mica particles treated with color-specific coatings designed to refract and reflect light are responsible for some pretty magical layers when used either as a paint layer or a glaze. There are also light-reflecting iridescent paints with a range of metallic effects, as well as the light-refracting colors known as interference paint. Even having just one of each of these particular magicians in your paint box can alter the way you see color. Any of these specialty paints can be mixed with your regular pigments to give them a unique color twist.

Interference glazes can shift a single blue background in several directions through glazing. If you like metallic, try a sheer wash of Iridescent Gold or Copper. The mica particles literally dance in the added water as the pigments float out from the acrylic binder.

These metallic paints can also be diluted with mediums to create varying densities of glaze, completely changing the surface of a painting. I always give caution as to the use of these pigments. Less is more since using a lot of these paints in one place can make things look like a disco ball.

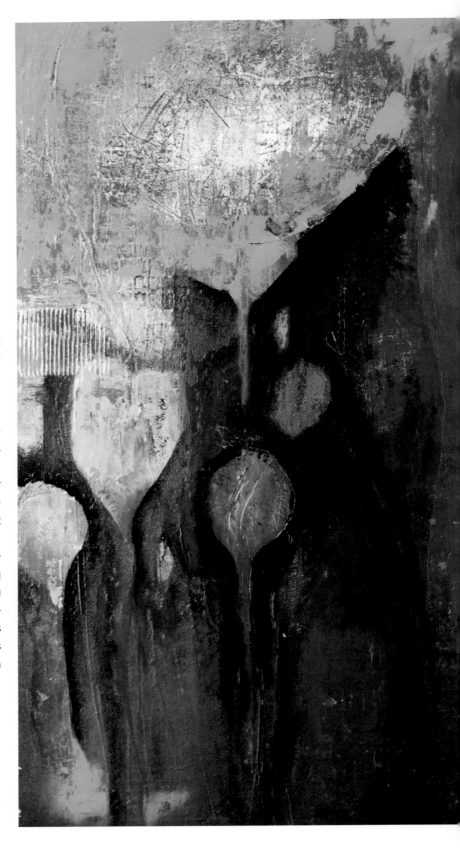

CANARY

Chris Cozen
Acrylic and mixed media on canvas
16" × 20" (41cm × 51cm)
Additons of Iridescent Gold and Micacious Iron Oxide give the surface a light-shifting effect.

Demonstration
MAGICAL LAYERS

There are times when a little sparkle and shine can do wonders for a surface. Iridescent and interference colors are the perfect vehicles for achieving that. These paints can be transformed by adding in just a bit of color.

MATERIALS LIST

assorted paints: Interference Blue, Iridescent Gold, Iridescent Pearl, Turquoise Phthalo

brush

painted panel

palette knife

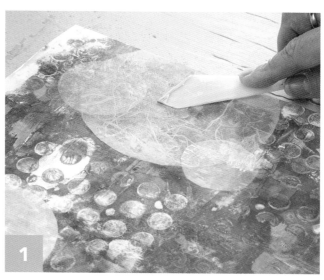

Start with an existing painted panel to which you'd like to add paint. Mix Interference Blue with a small amount of Turquoise Phthalo. Using a palette knife, apply the mixture of paint to random areas of the panel to shift the underlying colors. Let it dry.

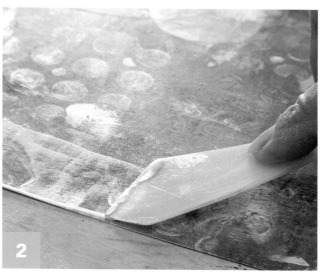

Use the palette knife to apply Iridescent Pearl to random areas of the painting to modify the colors below.

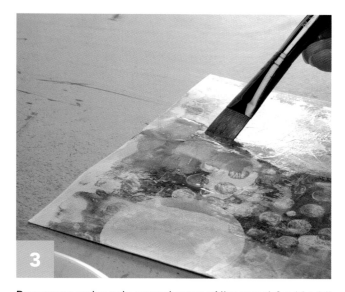

Drop some water onto several areas of the panel. Squirt a bit of Iridescent Gold onto the surface and add water to loosen the paint. Apply the loosened paint to the wet surface to create a sparkling wash in those areas.

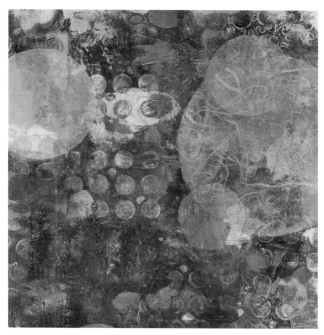

Muffled Glazes

Of all the techniques I have learned over the years, the one I use the most is a blocking glaze. In the early stages of my painting process I work very intuitively. For me it is all about picking up color and pulling it over a surface, spraying on diluted paint, dropping in high flow acrylics, splashing water over the newly painted areas, creating drips, etc. Once all these actions have dried on my surface, I use blocking glaze to discern the areas that need development and pushing back "what I don't want to see" with the glaze.

Look at the images on these two pages to get an idea of what that blocking glaze might look like. This technique is sometimes referred to as negative painting as it pushes back what you don't want to see, allowing the shapes you want revealed to become visible. These two images demonstrate the before and after.

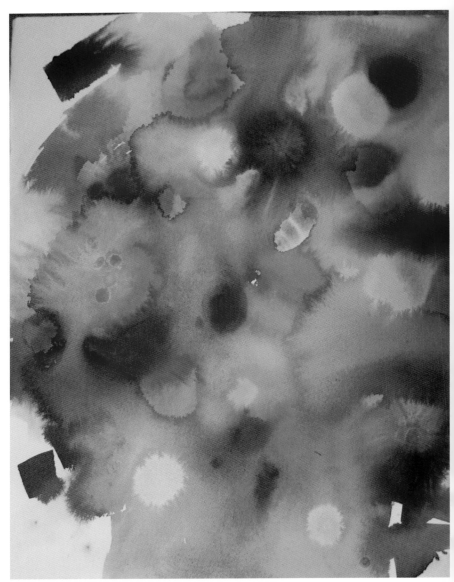

Before

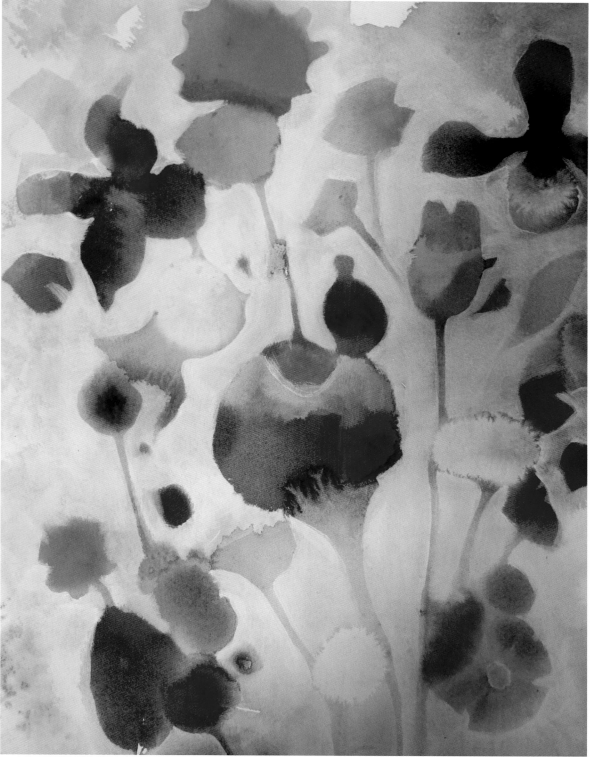

After

The blocking glaze is more opaque than a sheer color glaze as its primary purpose in this application is to cover areas or push them back visually. I usually work with 1:3 or 1:5 ratios. A blocking glaze works most effectively with an opaque pigment, but it can be mixed from a transparent pigment if you add a bit of Titanium White or Titan Buff to it. When I use this technique, I reach for these colors the most: Titanium White, Titan Buff, Teal, Cobalt Turquoise, Naples Yellow, Yellow Ochre, Chromium Oxide Green or a mixture of any of these colors with white.

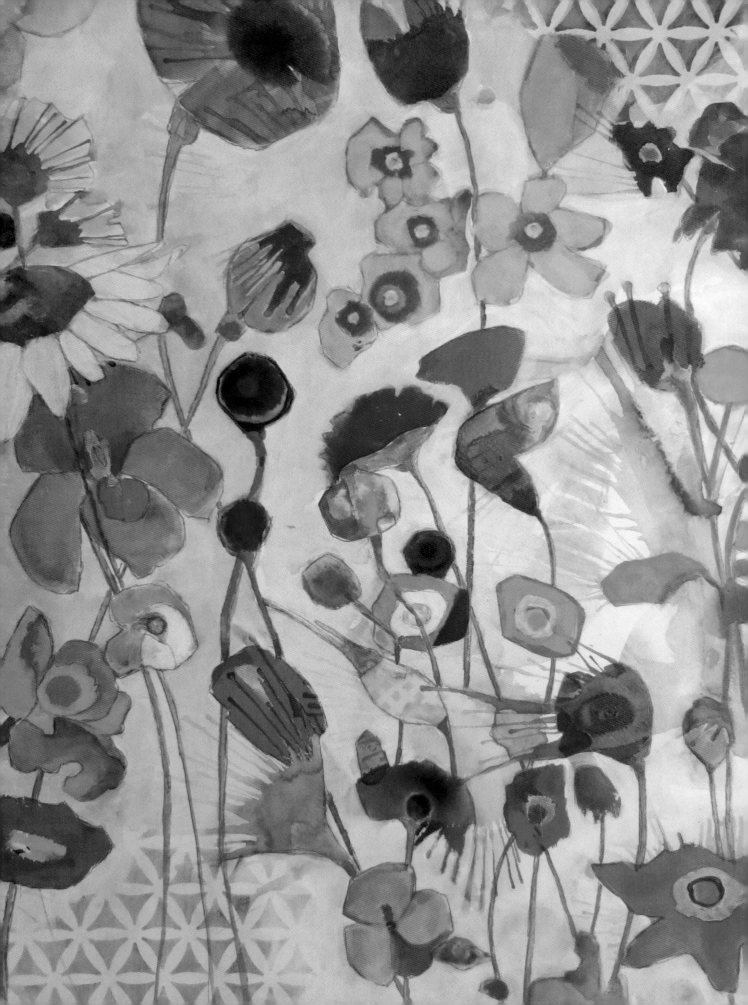

Muffled Glazes Variation

A variant on the blocking glaze uses regular or heavy gel matte to protect specific areas of the surface that you want to glaze on your painted surface. While the gel is wet, you can easily scribe marks, words or patterns into the surface. When the thicker matte gels dry, they leave behind a translucent area that rises slightly and the edges are readily visible. I like using this with stencils to create a raised pattern with a translucent surface.

After the gel is dry, the glazing begins. My preferred glaze for this use is a "dirty" glaze, which mixes a dark brown with a gritty product like Micaceous Iron Oxide or Iridescent Stainless Steel. The samples shown here readily demonstrate the surface transformation that can occur using these techniques.

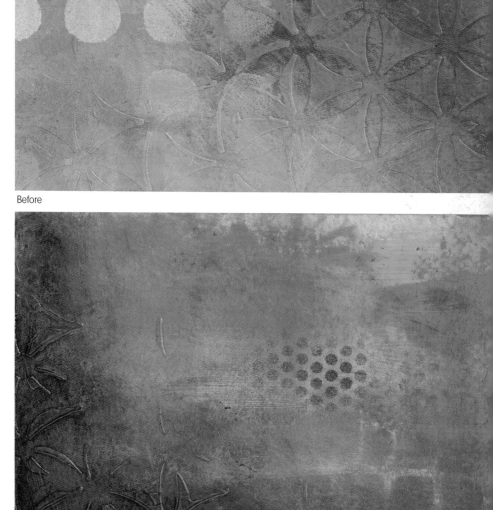

Before

After

FANCIFUL
Chris Cozen
Acrylic on watercolor board
20" × 16" (51cm × 41cm)
A blocking glaze is used to cover areas of a composition that are not essential. It softens the colors beneath and creates an unified layer, allowing the focal elements to be revealed.

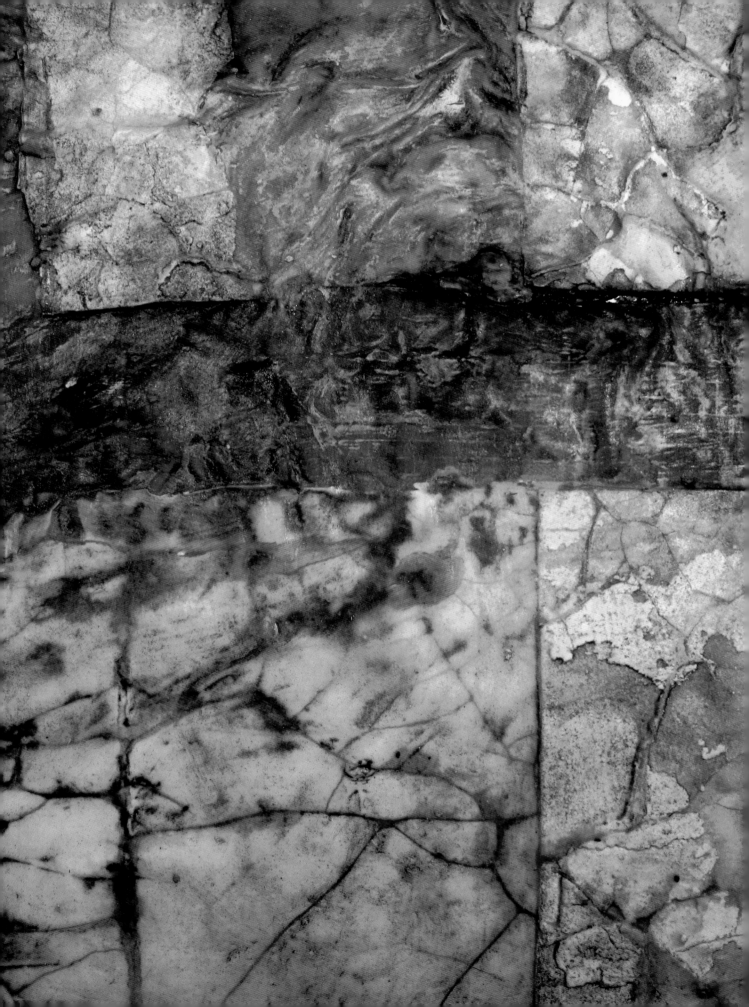

Evelyn CARO

I have a connection with Evelyn Caro through Golden Artist Colors, Inc. Evelyn lives in Calgary, Alberta, Canada and is a member of the Golden Artist Educator Program. As a member of this program, Evelyn teaches others about acrylics with a focus on experimentation and mixed-media techniques. I've chosen to place her work here because I think it demonstrates in a unique and interesting manner some of the techniques that we have just covered.

When I first came across her faux encaustic works, I was struck by their complexity and beauty. In Evelyn's words they are an "…exploration of textural sensations and a visceral response to the grittiness, smoothness, or slickness of the surface…My work is inspired by the journey itself; exploring and experimenting with acrylic gels and pastes to achieve all the different layers."

Her work will always hold glimpses of Quinacridone Nickel Azo Gold and Micaceous Iron Oxide as she feels that when combined they produce "beautiful rusty tones." Since she is "very attracted to distressed and aged surfaces," these two create a beautiful conversation together.

As many do, Evelyn benefits from her color mistakes. She shared one with me that I think bears repeating.

According to Evelyn, "One of the most important mistakes that I made in developing my color sensibility was [in] the use of black. Dirtier mixes were produced by adding black to darken or tone down a color. If I was not careful I could easily make mud. Eventually I learned that using a complementary color to tone down or darken a color offered a richer result."

FRACTURED
Evelyn Caro
Acrylic on panel board
10" × 8" (25cm × 20cm)

ABOUT
EVELYN CARO

Evelyn Caro is a working artist and instructor from Calgary, Alberta, Canada who focuses her practice on experimentation with acrylics and the utilization of mixed-media techniques. She strives to create organic abstract art. As a teacher she enjoys introducing new techniques and mediums to both the beginner and intermediate painter. Evelyn is a member the Golden Artist Educator Program.

I love pattern! It gives a lively energy to color and, when done well, can contribute rich texture and interest.

I have yet to meet Gwenn Seemel personally, but the first time I saw her work I smiled with delight. She is a master at utilizing both color and pattern to create her works of art. She is primarily a portrait artist, but she liberally includes animals in her subjects. Gwenn lives in Portland, Oregon where she works as an artist, writer and video blogger extraordinaire. She blogs in both French and English about numerous topics of personal and global interest. She credits the origins of her unique style to taking a class in intaglio printmaking while still in high school. Not really knowing how to draw when she started in the class, Gwenn picked up on the mark-making and cross-hatching aspects and has not stopped adapting since.

When you see her work you can see her obvious love of color, especially green. Her palette of Cyan Blue, Phthalo Blue, Green, Quinacridone Gold, Cadmium Yellow and Magenta, along with white and Burnt Umber conveys the energy and soul of her subjects.

Gwenn's pattern making is so beautifully woven into her compositions that initially you do not even see it. As you look closely you begin to see the intricacies she's developed. When you ask her how to define her style she simply says, "Gwenn Seemel…because it is simply a part of who I am, a very natural expression of me."

We'll take Gwenn's joyful use of color and pattern to heart and explore how it can help us convey our own color stories.

SELF—REPLICATING (BYNOE'S GECKO)

Gwenn Seemel
Acrylic on panel
10" × 10" (25cm × 25cm)

ABOUT
GWENN SEEMEL

Gwenn Liberty Seemel was born in Saudi Arabia and has lived most of her life in either Brittany, France or the United States where she learned to speak French fluently. Gwenn is a full-time artist who lives and works in Portland, Oregon. She paints mostly people and animals but sometimes other subjects as well. She writes and creates videos in both English and French, and is an active bilingual blogger on many subjects, including art. Seemel's art has been written about by the prominent portraiture scholar Dr. Richard Brilliant and featured in *Scientific American*. Gwenn spoke at TEDx Geneva 2014 about the importance of imitation to creativity and is known for her free culture advocacy.

BABY (CRADLE)
Gustav Klimt, National Gallery of Art
Oil on canvas
43 11/16" × 43 7/16" (112cm × 111cm)

I think the moment I first saw a painting by Gustav Klimt I became enamored of pattern and the possibilities it presented. When you pair pattern and color, those possibilities only compound. Just take a look at this painting by Klimt of a baby under a quilt in a cradle. The interior spaces he created are filled with detail and shifts in color and pattern.

PLAYING WITH PATTERN

The easiest way to start playing with pattern within a composition is through stencilling. There was a time when stencils were hard to come by, but thankfully that time has long since passed. Now it seems there are new stencils out almost every week.

There are so many patterns available that have been designed for journaling, mixed media and art in general that it makes it hard to choose. Fortunately for us artists, stencils are infinitely reusable, which makes them a sound investment. I find that stencil patterns that are nonrepresentational are the most versatile for adding shading, nuance and interest to areas of color as they tend to meld into the composition more easily. I am sure you can see why it would be much more difficult with a bird or a bunny pattern. With stencils I can quickly shift an underlying blue area towards either lavender or purple by adding a layer of pattern that contains a bit of pink. This visual color mixing is one of my favorite techniques, as seen below.

When you use two or more stencils in a composition, make sure to consider the scale of the pattern. The smaller pattern can be utilized to create volume, dimension or to add detail within larger patterns.

In addition to considering the pattern scale of your stencils, keep in mind the compatibility of the various patterns with each other. By having large, medium and small scale patterns available that work with each other, you can fit patterns into almost any space, shape or section of a composition with ease.

Use only as much of the stencil as fits seamlessly into your composition. This way you can avoid hard edges and keep the pattern flowing in a natural and organic way. A pattern needs to "fit" into a space for it to feel natural when viewed. Feathering out the edge of your stencil applications by gradually lightening your pressure on the tool you're using to pounce color through the stencil will give the technique a finished appearance.

It is also important to utilize a soft hand when stencilling. Using too much force can drive the paint below the surface creating a blurred or messy image. I recommend pouncing with a foam wedge or tool to transfer a light coat of paint through the stencil to the surface. To build up greater coverage, apply additional light coats of color. The key is to have as little paint as possible going through the stencil so the edges stay clean and sharp. Always keep in mind the interaction between the color of the background and the color of the paint used for the stencilling. You can create interesting optical effects with the proper use of stencils.

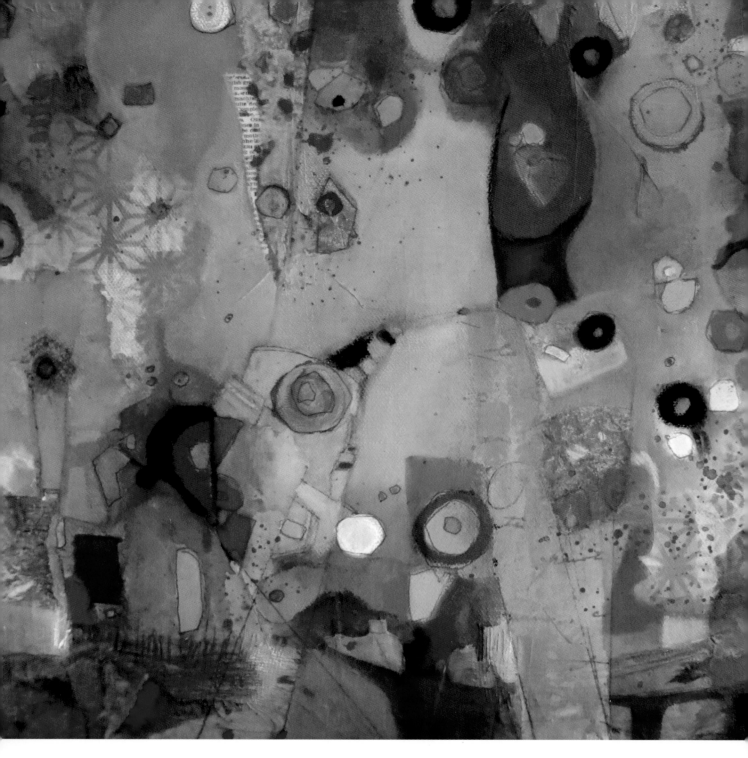

UNTITLED

Chris Cozen
Acrylic, graphite, oil pastel on canvas
12" × 12" (30cm × 30cm)
Create interesting spaces in your composition with blocks of color. Apply pattern in various ways
within those spaces. Add an additional layer of interest by applying a thin layer of Acrylic Ground for
Pastels over the surface of your paint and pattern. When dry this gritty layer allows you to draw with
pencil, add more color with pastels or color pencils. Every color layer plays a role.

Demonstration
LAYERED PATTERNS

Complex patterns are usually created in layers. This quick and easy technique can give you endless variations. Just remember to vary the colors and spacing so that you can take advantage of every color layer you apply.

MATERIALS LIST

alcohol

assorted paints: Cerulean Blue, Indian Yellow Hue, Magenta, Sap Green Hue, Titan Buff

brush

dropper or cotton swab

panel

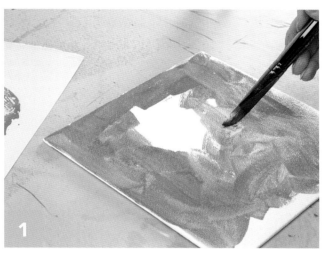

Create a wash of Cerulean Blue mixed with Titan Buff and apply it to the panel in random places, leaving some open spaces.

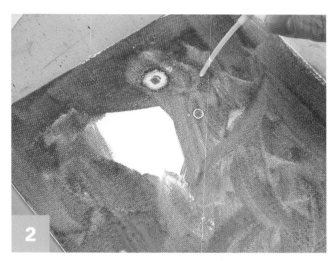

Use a dropper or cotton swab to drop alcohol onto the surface of the panel over the wet paint. Wherever the alcohol meets the watery paint, it creates a circular opening to reveal the surface below.

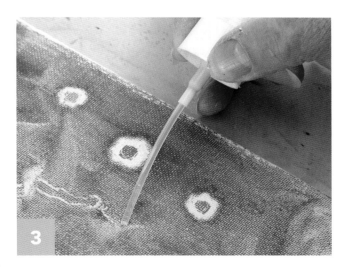

Draw on the surface of the panel with alcohol to create lines. Let the painting dry.

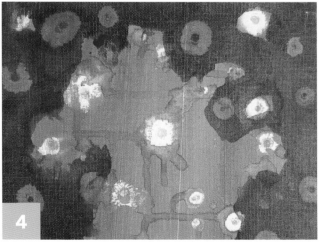

Apply a Sap Green and Titan Buff wash over the layer of blue, working around the previous areas of pattern. Then repeat steps 2 and 3. There should be areas with both white and blue circles on the surface.

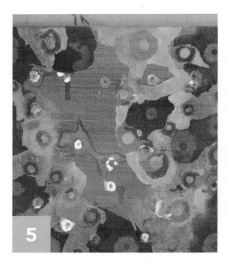

Add a third wash layer of Indian Yellow with Titan Buff and repeat steps 2 and 3. This layer will reveal green circles.

Apply the final wash layer of Magenta with Titan Buff.

Drop alcohol onto the wet surface to reveal more colors from prior layers. Let the panel dry.

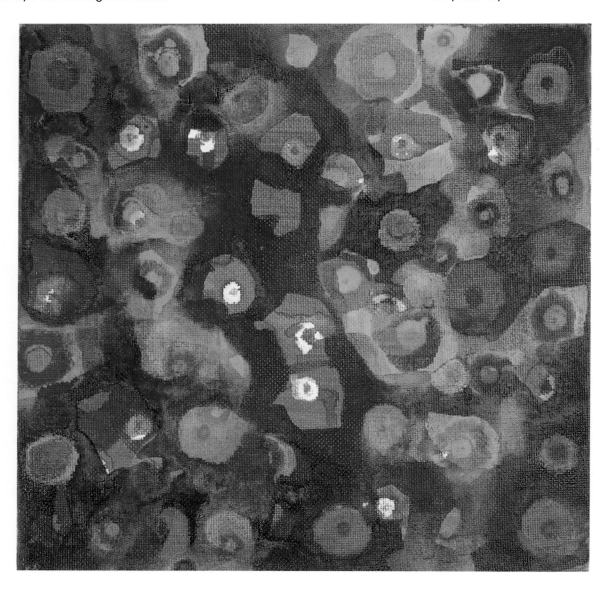

Check out artistsnetwork.com for free demonstrations and extra content.

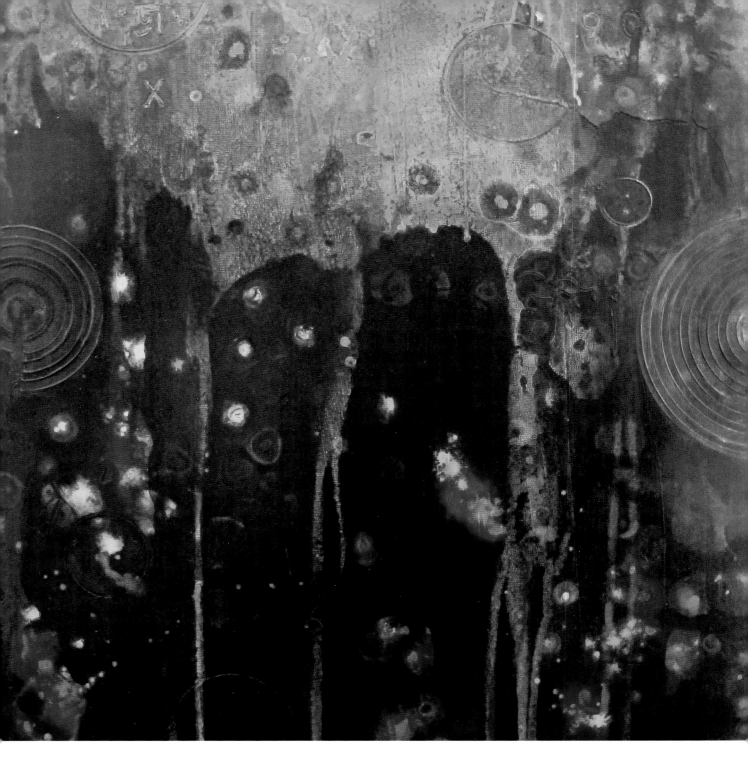

MILKY WAY

Chris Cozen
Acrylic on cradled panel
20" × 20" (51cm × 51cm)
The dramatic color interactions between the blue and black create the
framework for a dance of circles and colors. Repetition of forms within a
composition adds to visual cohesion.

RULE OF ODDS

Always keep in mind that odd numbers
of repeated colors or forms are more
interesting to look at than even numbers.

Demonstration
PULLING OUT WITH NEGATIVE PAINTING

Gelli plate prints are fun to make and a good way to practice your color skills. Here is a way for you to take them a step further. Negative painting allows you to isolate selected areas on a painted surface by surrounding them with another color. The outcomes are playful and exciting.

MATERIALS LIST

assorted paints: Bone Black, Prussian Blue Hue, Teal, Titan Buff

brush

Gelli plate print

white pen or chalk

Mark out some spaces using a white pencil or chalk on the surface of a Gelli plate print.

Create a dark mixture of Bone Black and Prussian Blue Hue and apply it to the print, maneuvering around the spaces you marked in step 1. Use a drybrush technique to soften the edges where you applied the dark paint, and use it to pull the color towards the center of the panel. Leave the center of the panel as it is. This layer should not be completely opaque. It's good to have some of the red peeking through the dark layer.

Mix a bit of Teal into the dark blue mixture to create a middle value.

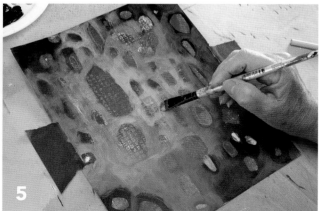

Apply this new Teal mixture over some of the wet areas of the dark mixture. Use a drybrush technique to soften the edges and blend the dark color with the Teal. Then pull the Teal over the remainder of the original red base.

Continue painting with the Teal around the various shapes you marked allowing some of the red base to peek through. Let it dry.

124 Check out artistsnetwork.com for free demonstrations and extra content.

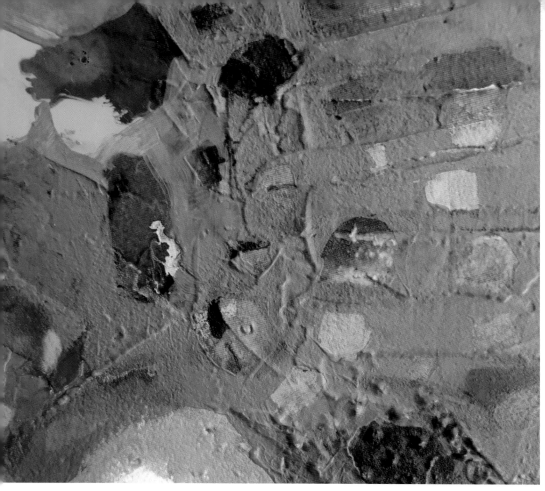

Details

Here's a detail shot of this technique done on a textured canvas surface in an alternate color palette.

This technique is equally effective using watermedia techniques on watercolor paper.

Demonstration
BROKEN COLOR PATTERNS

Recently I've become interested in how the Impressionists broke up their colors using combinations of light and dark strokes. The pattern and color interactions that occur are exciting, so this lesson explores a contemporary approach to this technique. Try experimenting with different combinations.

MATERIALS LIST

assorted paints: Cobalt Turquoise, Naphthol Red Light, Teal

brush

palette knife

panel or canvas

paper

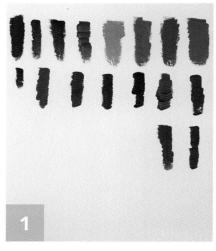

1 Create a color storyboard for your panel showing the color possibilities available with your paint choices.

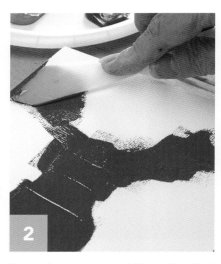

2 Apply large areas of Naphthol Red Light to the surface of your panel in an abstract shape.

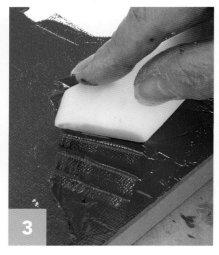

3 Apply Cobalt Turquoise in between two of the red areas. Then use the edge of your flat palette knife to cut into the turquoise areas creating linear openings. Follow the shape of the color blocks when creating your openings for a more organic look.

SMALL SPACES
If you're working in small spaces, you can use the edge of your brush rather than a palette knife.

4 Apply Teal to the remaining white areas on your canvas.

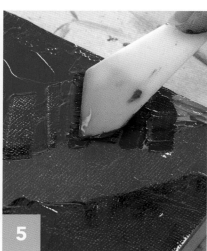

5 Load your palette knife with Naphthol Red Light paint and add it into the cut areas.

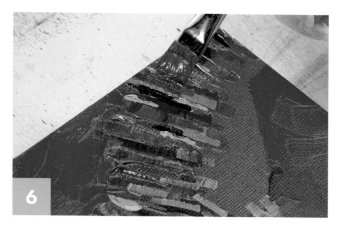

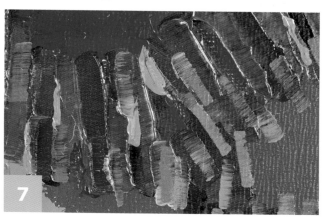

Create color variations using the original colors of the background layers, adding them flat to the surface in a linear fashion, following the original curve that was created with the cutouts. Use the palette knife to create openings for the next round of colors.

Repeat step 5 with multiple color variations. Stagger and stack the colors for more complexity. Let the panel dry.

patti MOLLICA

Meet Patti Mollica, a New York artist known for her "fast, loose and bold" style. As a painter, illustrator and instructor as well as my colleague in the Working Artist Program for Golden Artist Colors, Inc., Patti introduces people to color theory and a brushwork style that is fresh, unexpected and sassy. Which is very much like Patti herself!

She is not afraid to wield her brush in strong, powerful strokes when she paints a rose or to turn a dull sun-worn boat pink and yellow on her canvas. Patti told me that she "listens to her artistic voice which wants to express with color freely," yet on the other hand she stresses to "be mindful of the orderly relationship of colors and their characteristics…how they influence each other." Color theory provides a guide for playing with color freely and keeps her confident so that she can analyze any problems that might arise.

Quinacridone Magenta, Phthalo Blue, Cadmium Yellow Light and white make up the palette for many of her pieces. According to Patti this palette yields "gorgeous grays—and a painting with automatic color harmony." You'll readily see Patti's respect for neutrals and grays in her work. Beautiful shadows are cast from candy and cupcakes, to buildings and bicycles, all balancing the lively color schemes in which she paints. One might describe her work as "gestural with strong composition and simplified values." Patti credits this to her graphic design background.

Patti's style of painting is so completely different from my own, but her color sensibility resonates strongly with me. What I want to glean from Patti's work is that freshness. She approaches her subjects with a lively energy filled with confidence.

TIMES SQUARE BIKER
Patti Mollica
Acrylic on canvas
30" × 30" (76cm × 76cm)

ABOUT
PATTI MOLLICA

Patti Mollica has been a fine artist and professional illustrator for over thirty years. Her artwork is known for its fearless use of color and uninhibited brushwork. She is a certified Working Artist for Golden Artist Colors, Inc. and conducts workshops throughout the United States residing in Nyack, New York. Patti uses the sights and sounds of the city as inspirations for her dynamic paintings. She's represented in several galleries, and her published prints and posters can be seen in retail chains worldwide. Her instructional videos on painting are available through northlightshop.com.

CUTTING INTO COLOR

Since I'm not a figurative artist, I want to show you how I'd go about incorporating Patti's color sensibility and active strokes into my own art. When working with large strokes, I prefer to use a palette knife so that I can take advantage of all of its planes.

MATERIALS LIST

assorted paints: Hansa Yellow Medium, Naphthol Red Light, Quinacridone Magenta, Teal, Titanium White, Yellow Ochre

black gesso panel

brush

palette knife

rubber tool or comb

Apply a few drops of Teal paint to two places on a surface that has been prepped with black gesso.

Use a palette knife to scrape the Teal over the surface. Let it dry.

Smear Hansa Yellow Medium across random areas on the panel. Use the palette knife to spread it flat.

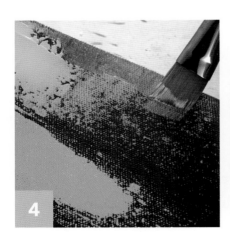

Feather some of the edges out with a brush, allowing the black surface to show through.

Spread Naphthol Red Light onto the panel's surface and allow some to overlap the wet Hansa Yellow Medium. Apply Titanium White to some remaining black areas and pull some of the other colors into the red by partially mixing them with the white.

Use the side of the palette knife to cut in and make spaces, mixing colors on the panel where the paint is still wet.

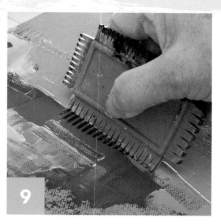

7 Add Yellow Ochre to the center of the panel between the Teal and red, leaving some of the black still showing. Then apply some of the Hansa Yellow over the top of it in some areas to bring the lighter yellow to the surface.

8 Add small amounts of Quinacridone Magenta where the white areas meet the red. Blend it slightly.

9 Use a comb or toothy rubber tool to scribe into the wet paint and let dry.

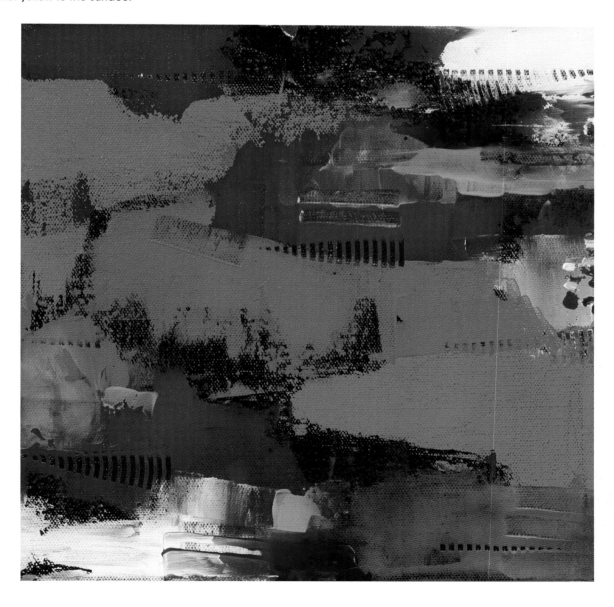

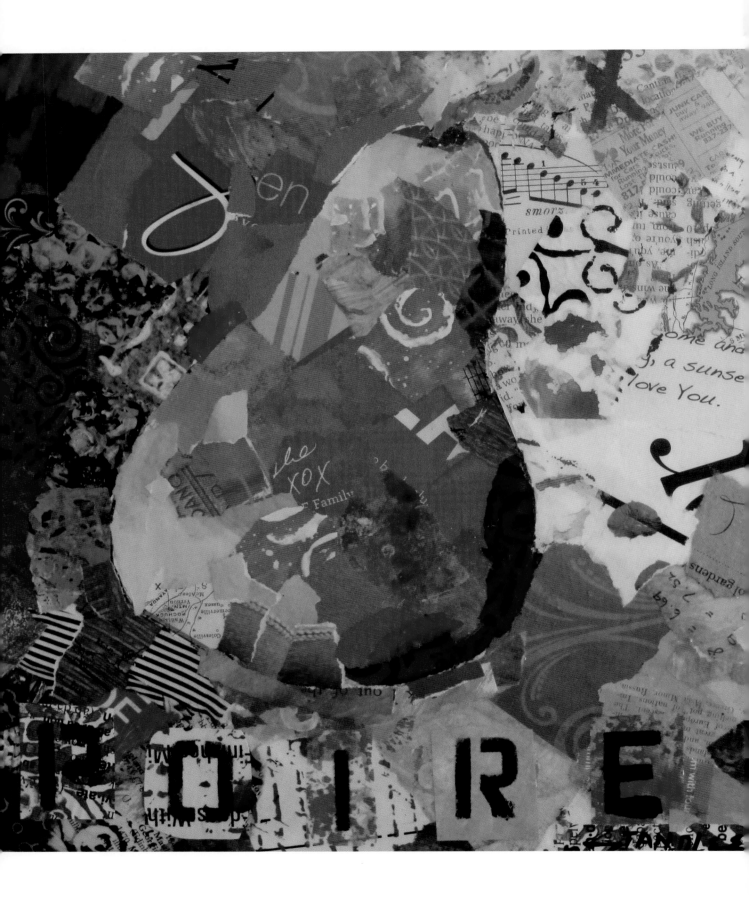

Nancy STANDLEE

The world is a fascinating place filled with so many artful people such as Nancy Standlee. We're actually "virtual" acquaintances, as we met when Nancy enrolled in an online class that I teach with Julie Prichard.

Nancy is an accomplished artist in many mediums, and she's always taking or teaching workshops. She paints in oil, acrylic and watercolor and works with collage. All of her work is characterized by a joyful, happy sensibility. According to Nancy, she takes inspiration from Marc Chagall's quote: "I work in whatever medium likes me at the moment."

I loved Nancy's exuberant take on collage the moment I saw it. She takes an idea and runs with it. Nancy is a great lover of color, but she clearly understands how important it is not to overstimulate her viewer's eyes with too many colors at once. Utilizing black somewhere in her collage work, usually through letter shapes or line, gives her compositions pop and interest. You can also count on finding something in the red family in every piece Nancy composes, anywhere within the analogous range of purple through orange.

With her broad experience in many art forms, Nancy often makes her own collage papers to add to her many found sources. When I asked Nancy for some color advice, she stressed the importance of graying down some colors in your palette to develop a greater range of values and ensuring color harmony with the composition. It's a valuable lesson regardless of the medium in which one works. Let's put some of her mixed-media lessons to work.

POIRE
Nancy Standlee
Paper collage on canvas
10" × 10" (25cm × 25cm)

ABOUT
NANCY STANDLEE

Nancy Standlee is an Arlington, Texas, award–winning contemporary artist who works across several mediums. She's known for her boldly expressive work with joyful subject matter. Nancy was a school librarian before retiring in 2000. In addition to painting and blogging, Nancy teaches art journaling and collage workshops. She is also a signature member of the Society of Watercolor Artists in Fort Worth and is known for her art tutorials on www.dailypaintworks. com where she sells her work. She is a published artist who has her work in books as well as on menus.

Demonstration
SUPPORTING PAPER WITH PAINT

I'm always grabbing bits and pieces of paper to tweak the color areas of something I'm working on. I like the complexity it lends to the painted surface because I can tear papers to whatever shape I need them and easily fit things into unusual spaces or expand a painted area to increase its visibility.

<div>

MATERIALS LIST

assorted papers
matte medium
painted surface
palette knife

</div>

1

Arrange your papers on a previously painted panel. Tear the papers to fit into smaller spaces.

2

Cut or tear multiple papers into similar shapes to layer and echo one another.

3

Adhere the papers to the panel with a palette knife using matte medium. Continue to layer the papers and adhering them onto the panel. Make sure to use papers that provide for both dark and light values, just as you do with paint. Let them dry.

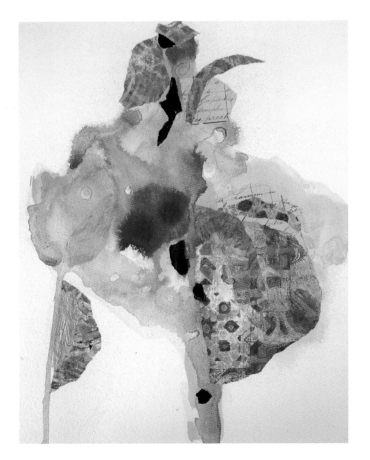

PAPER SOURCES

Be in charge of your own paper sources by making or modifying them yourself. Find out how by visiting: artistsnetwork.com/acrylic-color-explorations

Demonstration
PAINTED DEEP TONE PAPERS

Dark and deep toned papers are needed to add value and contrast to mixed-media compositions. Many times, purchased papers fade quite easily, especially in the deeper tones. By working with paints over archival black papers you can create your own supply of papers without worrying about fading. Tearing these black-based papers provides a strong line that is ideal for collage detail. Here are four variations of patterns that you can use with numerous color combinations. Always pair a pigment color with interference or iridescent colors for maximum benefit.

MATERIALS LIST

assorted paints: Dioxazine Purple, Interference Blue, Iridescent Gold, Iridescent Gold Deep, Iridescent Stainless Steel, Micaceous Iron Oxide, Prussian Blue Hue, Raw Umber

comb or a carving tool with teeth

glazing liquid

palette knife

paper

sponge

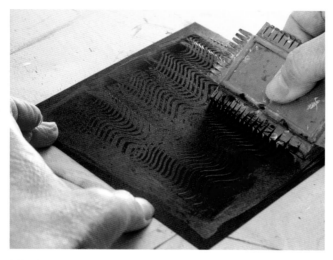

Mix Dioxazine Purple, Interference Blue and glazing liquid together. Apply it to the surface of your paper and pull a comb through it.

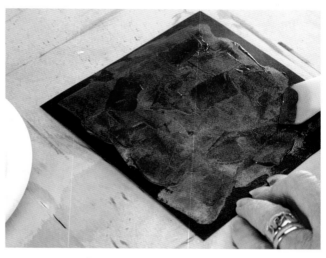

Mix Dioxazine Purple, Interference Blue, glazing liquid and Stainless Steel together. Apply it to the surface with random small swipes of the palette knife.

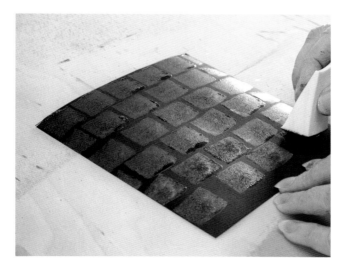

Mix Prussian Blue Hue, acrylic glazing liquid and Iridescent Gold. Then apply the mixture to the surface with a sponge in a repeating pattern. You can vary the spacing or add a second layer with a new color.

Mix Micaceous Iron Oxide, Raw Umber and Iridescent Gold Deep. Apply the mixture to the surface by dragging your palette knife across the page.

Demonstration
PUTTING IT ALL TOGETHER

In this demo I'm using a number of the color lessons and techniques we've covered in these pages by painting in my own style. There have been many lessons throughout this book that can be utilized in anyone's work. I hope you will try them all over time.

MATERIALS LIST

alcohol

assorted paints: Bone Black, Hansa Yellow Medium, Phthalo Blue (Green Shade), Phthalo Green (Blue Shade), Quinacridone Magenta, Titan Buff, Titanium White, Turquoise

brushes, including fine tipped

glazing liquid

knitting needle, chopstick or pointed tool

panel

pencil

straw

water

1

Use a wet brush to paint uneven circles of water onto the surface of the panel in at least three areas. Drop some Magenta paint into the center of the circles. Around one of the circles add an additional ring of water and drop Hansa Yellow around the outside of the Magenta but within the wet circle.

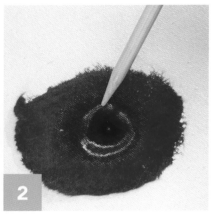

2

Drop some alcohol drops into the center of the painted circle to create an opening. Use a pointed stick to draw a circle with the alcohol around the opening.

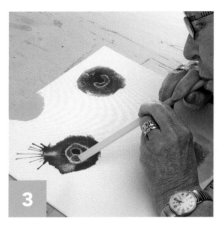

3

Position the end of a straw near the outside edge of the circles. Blow into the straw close to create a fan pattern. Repeat for all of the Magenta circles.

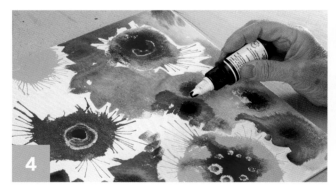

4

Wet some of the remaining white areas of the canvas with water. Drop in some Phthalo Green onto the new wet areas. Add drops of Phthalo Blue directly onto the green areas—where they meet, they will bloom.

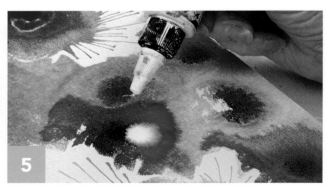

5

Add some Titanium White onto the blue areas.

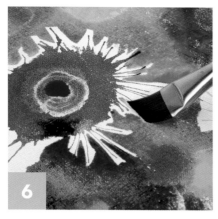

6

Use the edge of the brush to cut in between the colors to make marks.

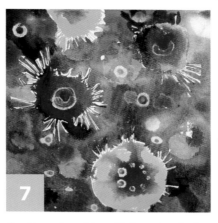

7

Continue to add multiple colors to the canvas until the white of the canvas is covered. Let the surface dry.

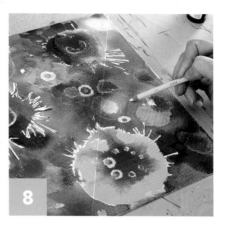

8

Pencil in some flower shapes.

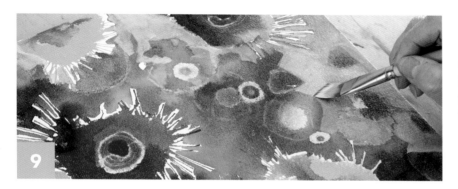

9

Create a blocking glaze using Titan Buff and glazing liquid to push back the background and pull some shapes forward.

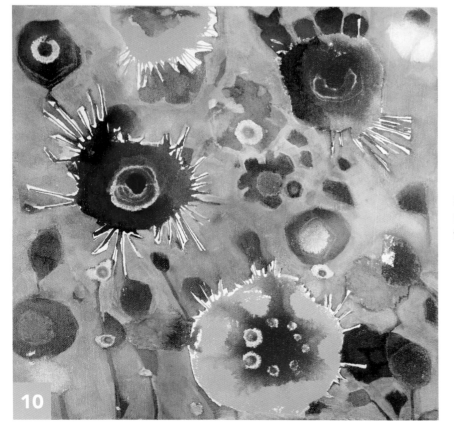

10

Use two coats of the blocking glaze if necessary. The green areas should show through slightly.

11 Use some bold strokes to enhance the interior of the flowers, playing off the colors already there. Add some details.

12 Go over the background with a mix of Turquoise, Titan Buff and glazing liquid to push back any busy areas remaining.

13 Use a fine brush to add fine black details to the center of the flowers and stems.

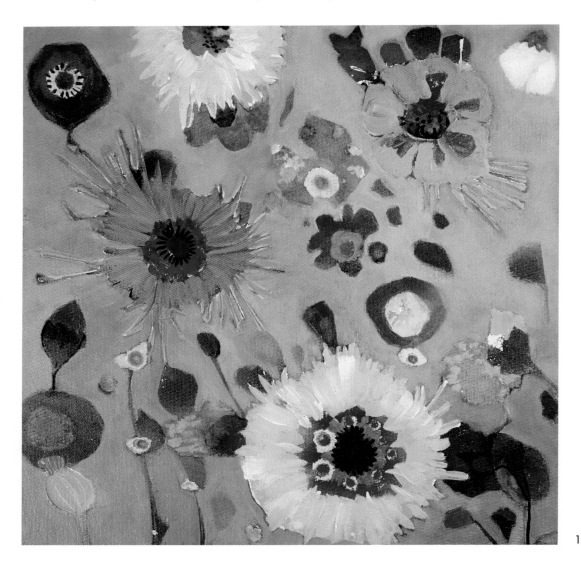

CIRCLING
AROUND
Chris Cozen
Acrylic on paper
12" × 9" (30cm × 23cm)

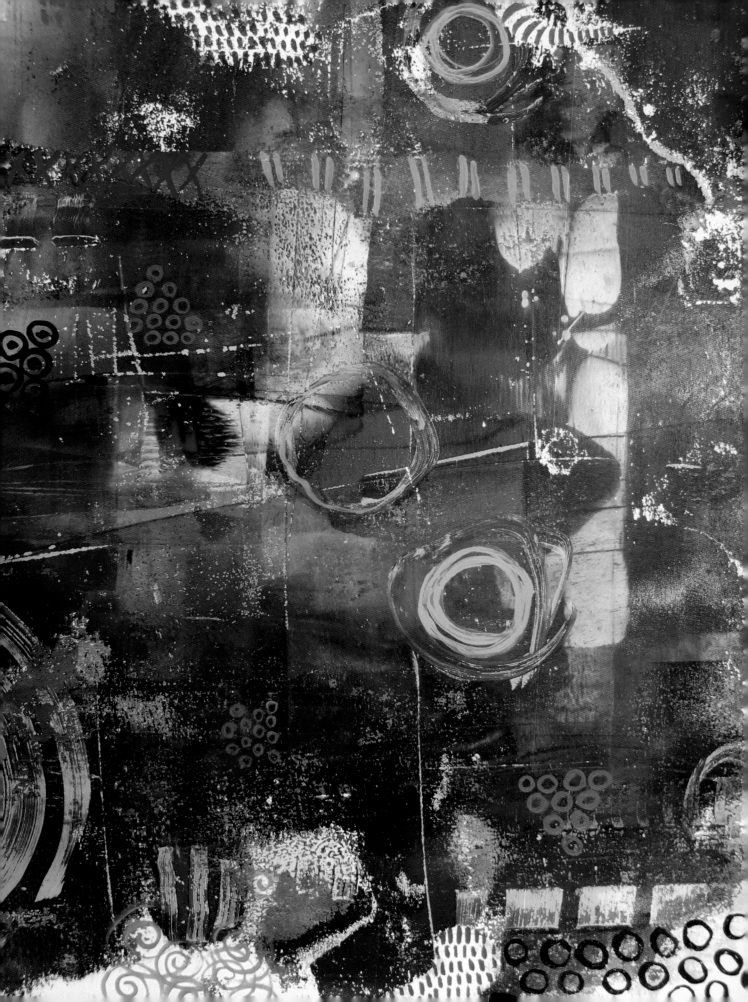

CONCLUSION

Before I wrap up, I want to offer some thoughts about working in color layers. I've learned that utilizing layers in your work can bring a level of depth and complexity that isn't otherwise possible. I encourage you to begin thinking of color in this way. One layer of paint is simply just not enough! By varying the manner in which you apply your layers, your surfaces will speak in a rich and textured voice.

Remember that how we use color is subjective, and when we use it we express our own opinions. Only through time and experimentation will you discover where your own color sensibilities lie. Take the time to fully explore the breadth and depth of the entire conversation color brings to art. Whether you explore the full range of the color wheel or prefer to stay within a small segment of it, understanding the mechanics, theory, reality and application of color in all its full glory can only help make you a better artist.

I cannot encourage you enough to play and explore color, to explore the colors you already have, to experiment with new ones and attempt to replicate the colors you see in the world around you. If you make mud along the way, so be it. Figure out what you have done so you can know what not to do the next time. Every once in a while try to stray out of the color place that feels safe. Take some color risks. The more you experience color, the better your color sense will become.

Always keep in mind that every pigment has a specific voice and the combination of two pigments creates another unique sound whose volume can be increased or decreased with a number of techniques, some of which you've learned in these pages. White, black and gray are always ready to join into any color conversation you enter, bringing with them their own lightness or depth and enriching your palette with their nuance. Every lesson in this book is an investment in a process that will pay tremendous returns in your own work. Just as in any good conversation, you get out of it what you put into it. The diversity of contributions from the guest artists is a clear indication that color can be utilized to say anything you wish—whether it is joyful or somber, earthy or high key. Find your own color voice and express yourself. I'll be waiting to hear (and see) what you have to say!

Artfully yours,
Chris

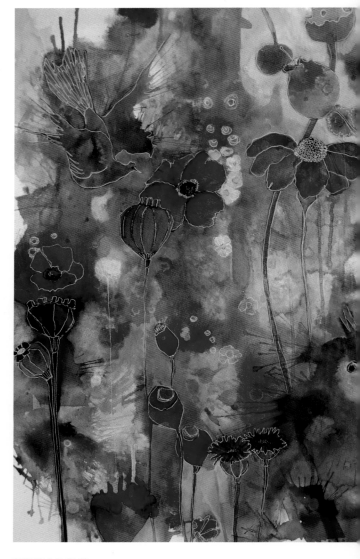

PEEKABOO
Chris Cozen
Acrylic on watercolor board
30" × 24" (76cm × 61cm)

INDEX

acrylic ink, 61, 111–114
alcohol drops, 121–122, 136–138

beads, 108, 115
black-and-white images, 15
blacks, 18, 20, 24–25, 140
bleeds, 115
broken color technique, 65
browns, 20, 54
brush strokes, 67
brushes, 5

Caro, Evelyn, 105
chroma (saturation), 11–12, 33
collage elements, 9, 91–92, 108–109, 134
color(s), 10–15
 analogous, 14, 58, 60–61
 blending, 72
 complementary, 14, 16, 62–63, 67
 cutting in, 130–131
 experimenting with, 6, 140
 harmony and balance in, 14–15
 integrating, 61
 layered and brayered, 30–31
 layers of, 140
 monochromatic, 14, 46–49
 neutral, 17–18, 20, 38, 50, 63
 nuance within, 21
 split complements, 75
 toning down, 33
 See also blacks; browns; grays; greens; reds; whites
color mixing, 37
 chromatic blacks, 25
 chromatic whites, 22–23
 complementary grays, 27
 complements, 67
 monochromatic palette, 49
 neutral colors, 50
 primary grays, 27
 surface mixing, 60–61
color schemes
 mixed-media, 53
 monochromatic, 46
 split complementary, 75
 triadic, 76–77
color temperature, 12, 17, 38
 raising and lowering, 39
 warm vs. cool, 17, 38, 58
color voice, 6, 17, 44, 76–78, 93, 110
color wheel, 13, 34, 36–37
 See also palettes

Doh, Jenny, 80–81

en grisaille, 55
ephemera, 91–92

Fauvism, 36, 62
faux encaustic, 104–107

Gelli plate, 56, 124
Glass Bead Gel, 108, 115

glazes and glazing, 11, 93–94
 blocking, 100–101, 137
 interference, 98–99
 muffled, 100–103
 specialty, 98
 transparent (sheer), 93–94
glazing liquid, 71, 91, 135, 138
grays, 20, 50, 140
 chromatic, 25
 complementary, 26–27
 neutral, 24
 primary, 27
grayscale, 12, 26
greens, 43

Heavy Body paint, 30, 60, 130
High Flow Acrylics, 60, 111–113
hue, 12

Impressionism, 36, 40, 67, 126

journaling, 119

layers and layering, 71–73, 99, 140
lightfastness, 12

mass tone, 11
Matisse, Henri, 36–37
Menendez, Mark, 64–65
Meyer, Chris, 52–53
mica particles, 98
mixed media, 53, 106, 119
mixed-media papers, 56–57
molding pastes, 108, 110, 115
Mollica, Patti, 128–129
mother color, 50–51

negative painting, 124–125
negative shapes, 66
neutral colors, 17–18, 20, 38, 63

Open Acrylics, 30, 92
origami mesh, 95–96
oxidation, 10

paint skins, 108–109
paints, 98
 See also Heavy Body paint; High Flow acrylics; pigments
palettes
 analogous, 46, 58

basic color wheel, 36
 limited, 86–87
 Matisse color wheel, 37
 Monet color wheel, 40
 monochromatic, 46–49
 softened, 40
paper(s)
 collage, 57, 106, 133
 Japanese, 95
 layering, 95–96, 134
 sources for, 134
 tissue, 95
paper cutouts, 36, 66
patterns, 119
 broken, 126–127
 with bubble wrap, 30
 layered, 121–122
 See also stencils
pigments, 5, 10–12
 opaque (natural), 42–43
 See also colors; paints
Prichard, Julie, 28–29

reds, 39, 85
reusing/recycling, 57, 109
rule of odds, 123

safety issues, 10, 40
scratching, 30–31
scribing, 103, 131, 135
Seemel, Gwen, 116–117
shades, 12, 14, 17
stamping, 30
Standlee, Nancy, 132–133
stencils, 56–57, 88, 103, 115, 119
storyboard, 51, 76, 126
surfaces, 5
 absorbent, 110
 See also paper; Yupo

texture, 31, 109, 125, 131, 135
tints, 12, 14, 17, 21, 92
tone, 12

value, 12, 14, 55, 58
Van Gogh, Vincent, 62–63

washes, 95, 98–99, 114, 121–122
watermedia techniques, 26, 85, 125
whites, 18, 20–23, 140

Yupo, 110, 112

CONTRIBUTORS

Evelyn Caro
evelyncaro.com
facebook.com/Evelyncaroartstudio

Jenny Doh
crescendoh.com
facebook.com/jenny.doh

Sharla Hicks
sharlahicks.com
acebook.com/
groups/245500748982332
(Tangled Expressions with Sharla Hicks)

Mark Menendez
menendezartstudio.com
facebook.com/menendezart

Chris Meyer
chrismeyerart.com
facebook.com/ChrisMeyerArtist

Patti Mollica
mollicastudio.com
facebook.com/pages/Patti-Mollica-
Art/671833456194944
newyorkpainter.blogspot.com

Julie Prichard
julieprichard.com
facebook.com/JuliePrichardArtist

Gwenn Seemel
gwennseemel.com
facebook.com/gwennseemel

Nancy Johnson Standlee
nancystandlee.com
nancystandlee.blogspot.com
facebook.com/nancystandleefineart

METRIC CONVERSION CHART

To convert	to	multiply by
inches	centimeters	2.54
centimeters	inches	0.4
feet	centimeters	30.5
centimeters	feet	0.03
yards	meters	0.9
meters	yards	1.1

REFERENCES

Monet's paint applications:
nationalgallery.org.uk/monets-palette-in-the-
twentieth-century-water-lilies-and-irises

Other fine North Light Books are available from your favorite bookstore, art supply store or online supplier.
Visit our website at fwcommunity.com.

19 18 17 16 15 5 4 3 2 1

DISTRIBUTED IN CANADA BY FRASER DIRECT
100 Armstrong Avenue
Georgetown, ON, Canada L7G 5S4
Tel: (905) 877-4411

Edited by **brittany vansnepson**
Designed by **laura kagemann**
Production coordinated by **jennifer bass**

DISTRIBUTED IN THE U.K. AND EUROPE
BY F&W MEDIA INTERNATIONAL LTD
Brunel House, Forde Close, Newton Abbot, TQ12 4PU, UK
Tel: (+44) 1626 323200, Fax: (+44) 1626 323319
Email: enquiries@fwmedia.com

DISTRIBUTED IN AUSTRALIA BY CAPRICORN LINK
P.O. Box 704, S. Windsor NSW, 2756 Australia
Tel: (02) 4560-1600; Fax: (02) 4577 5288
Email: books@capricornlink.com.au

ISBN 13: 978-1-4403-4077-2

ABOUT THE AUTHOR

Chris Cozen is a self-taught acrylic and mixed-media artist, teacher and author. She spent nine years as a Working Artist for Golden Artist Colors, Inc. and is currently a member of their Artist Educator team. She shares the knowledge and understanding of acrylics that she gained through training students in both hands-on workshops and online instruction. Originally trained as a teacher, Chris brings all of her educational skills to the table whenever she teaches, writes or shares information on her blog. Her book (with co-author, Julie Prichard) *Acrylic Solutions: Exploring Mixed Media Layer by Layer* is a favorite among both beginning and experienced mixed-media artists. She lives and works in Southern California but takes inspiration from wherever she goes. Chris always travels with a camera with the expectation that there will be something wonderful to see.

FIND OUT MORE HERE

chriscozenartist.com
facebook.com/Chriscozenart
chriscozenartist.typepad.com
chriscozen@aol.com
Online classes: thelandoflostluggage.com/new-products-1

ACKNOWLEDGEMENTS

Thank you to Golden Artist Colors, Inc. for your commitment to quality and service to artists across the world. I am proud to be a part of your team.

A special thanks goes to my husband, Darrell, who has put up with my long studio hours and days at the computer. His patience is greatly appreciated.

Thank you to all of my contributors for allowing me to share their work so that others might learn.

Thanks to the the entire F+W team who worked to make this happen from concept through completion.

DEDICATION

This book is dedicated to all of my students over the years. You are the inspiration for these pages. Your questions always lead me to discover things I don't yet know. Your enthusiasm for art created a proving ground for many new techniques over the years. Thank you for trusting me to guide you, for allowing me to share my love of color with you and for fearlessly jumping right in with me. Make me proud, go paint "out loud!"